Cartoon
REFUGE

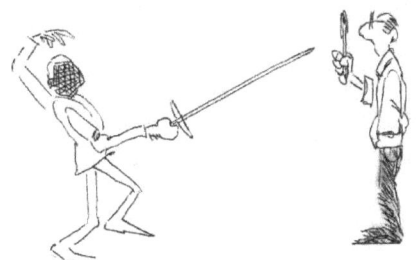

Cartoon REFUGE
Summer 2024

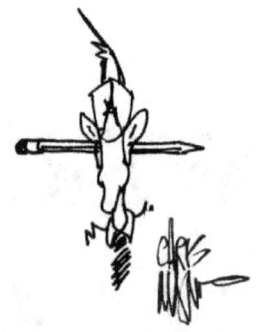

© 2024 Chris Manno
All Rights Reserved

ISBN: 9798333940735

Printed in the United States of America

Cartoon REFUGE
Summer 2024

```
Ref uge /ˈrefyo͞oj/ the condition of
safety and shelter.
```

And everyone knows what a cartoon is, so this project: protecting the nearly extinct art of cartooning from the media kudzu that is the GIF and Meme. Don't get me wrong—both modalities have their time and place in semiotics and expression. But the crowd-sourced aspect of those social media hatchlings eradicates the art of drawing, relying on extant pictures or symbols combined with witty (sometimes) phrases. Meanwhile, the simple line, hand-drawn, dies a slow death.

Now here's an ark, sailing west on a sea of semiotic expression, preserved from extinction (I hope) by the archival nature of this collection. They're all original, hand-drawn with pencil first, then my pen of choice: the rock-bottom Bic ballpoint.

Full disclosure: I have no formal "art" training, so I have no real aesthetic authority—I just know what I like: the classic cartoon style of Herman Unger, Jeff MacNelly, Johnny Hart, Chic Young and so many other old-school masters of the simple line cartoon humor.

Long may that artistic tradition continue. Have fun, enjoy; save and share these cartoons.

CM

Cartoon REFUGE
Summer 2024

Cartoon REFUGE
Summer 2024

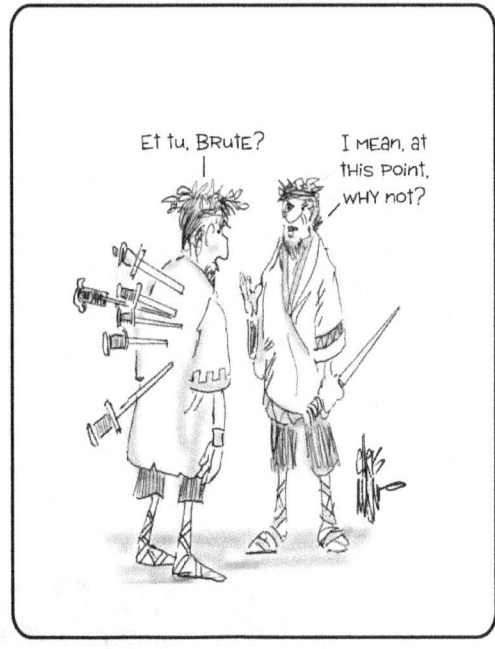

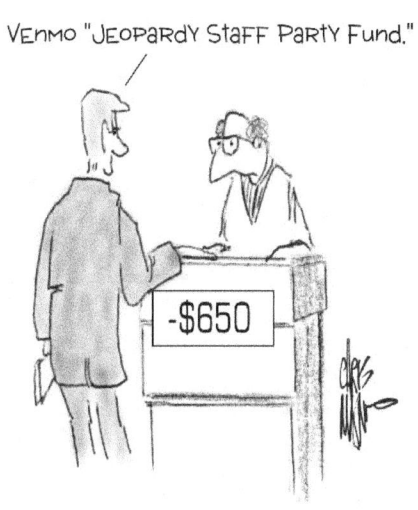

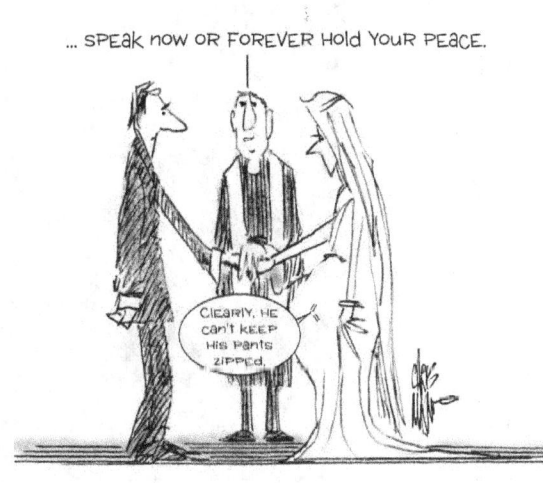

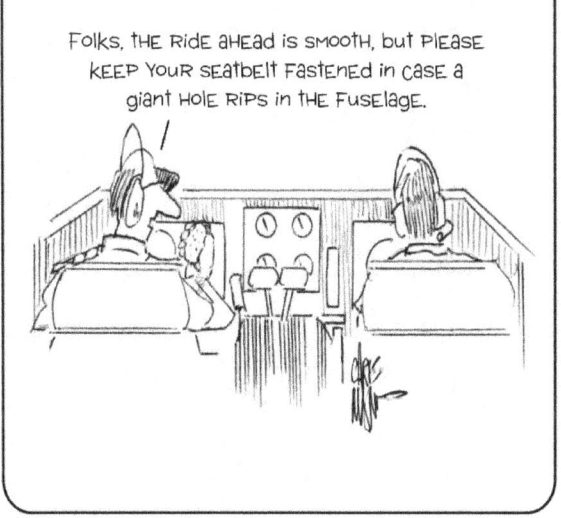

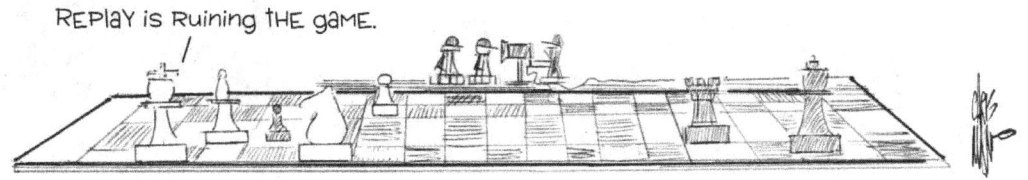

Cartoon REFUGE
Summer 2024

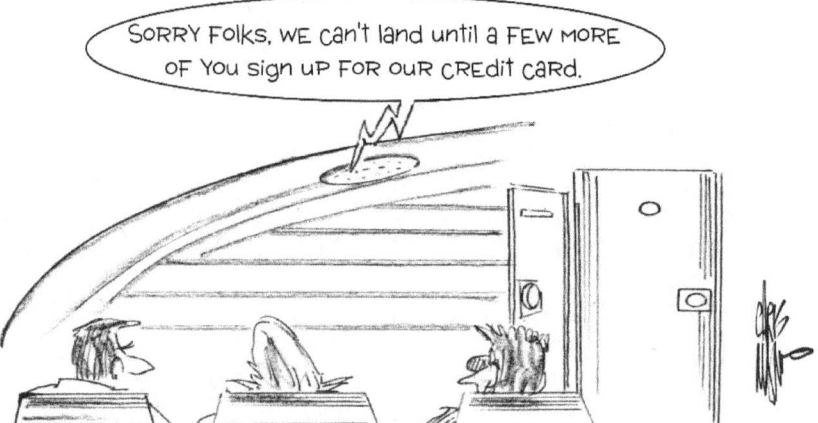

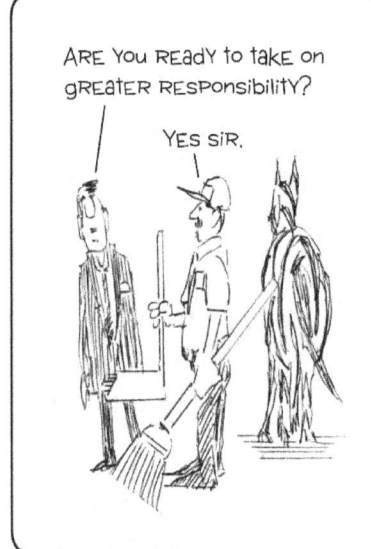

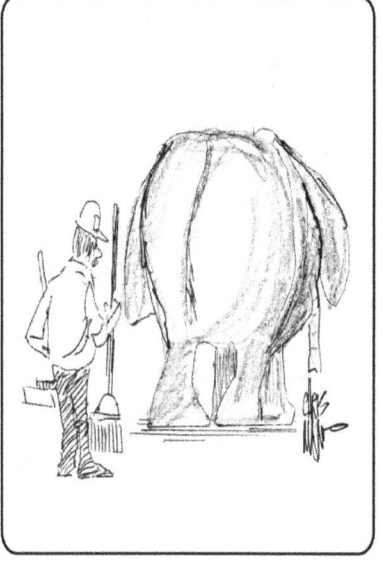

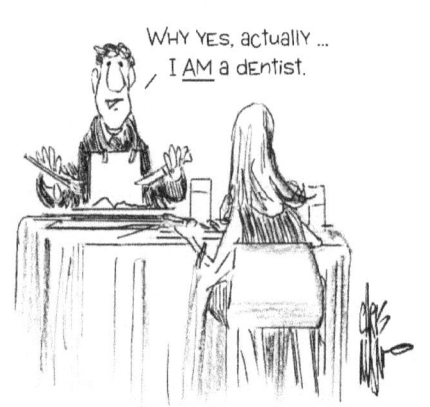

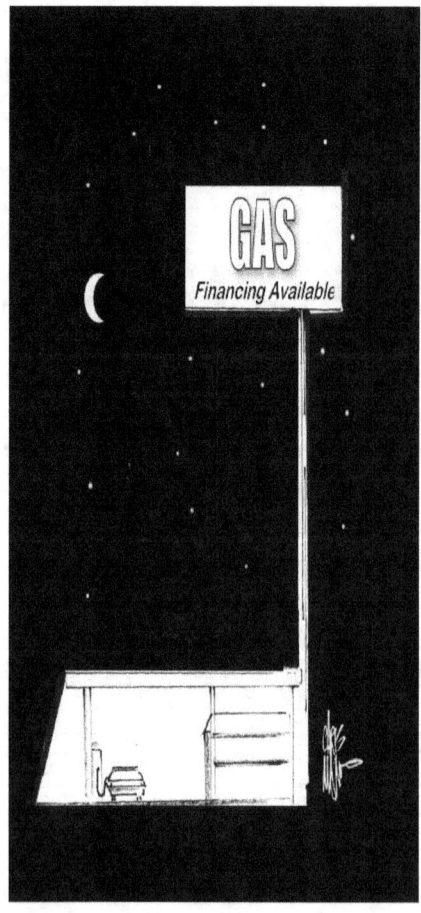

Cartoon REFUGE
Summer 2024

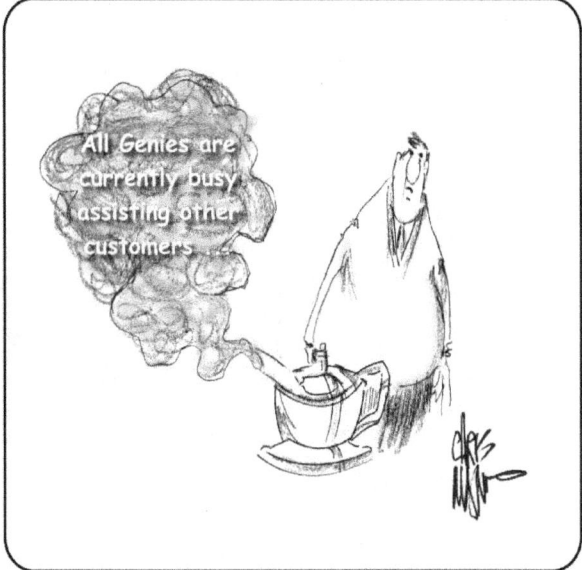

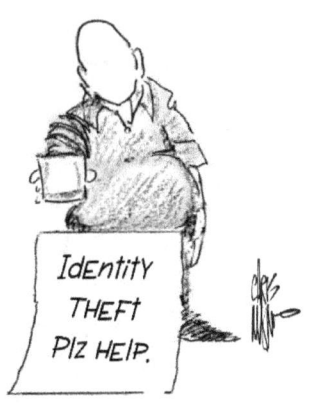

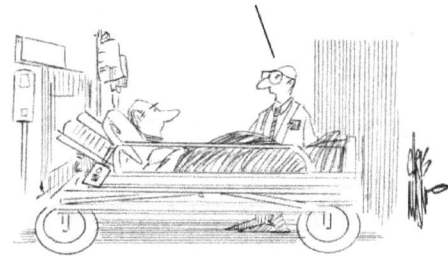

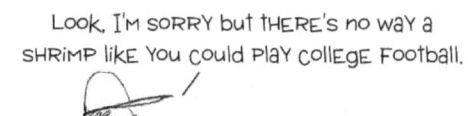

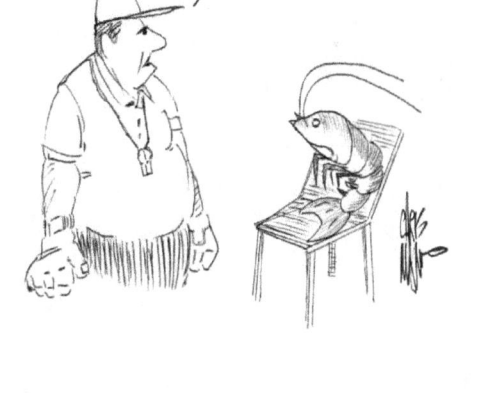

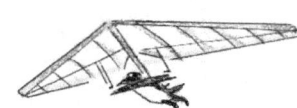

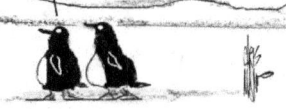

Cartoon REFUGE
Summer 2024

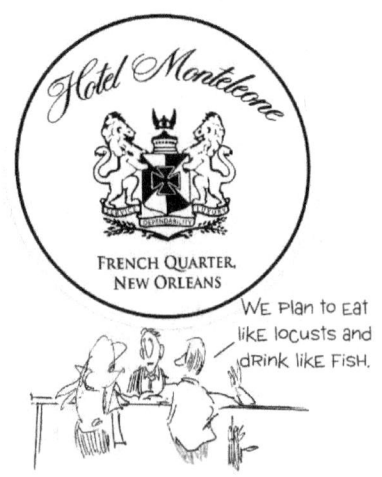
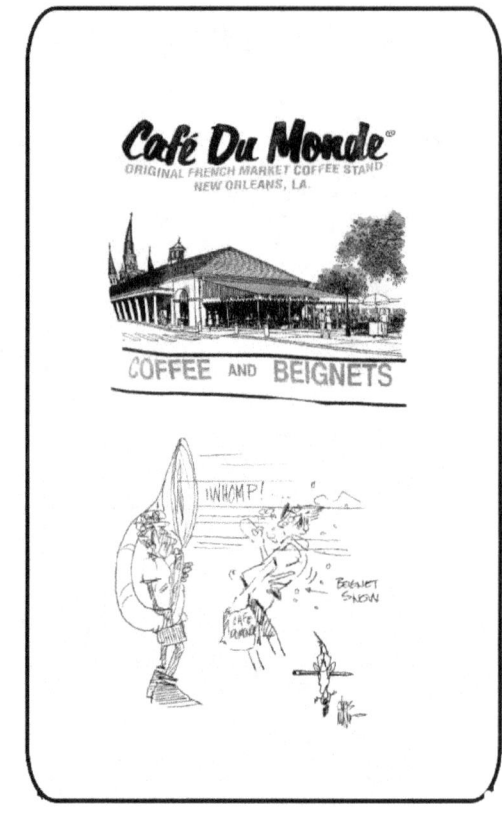
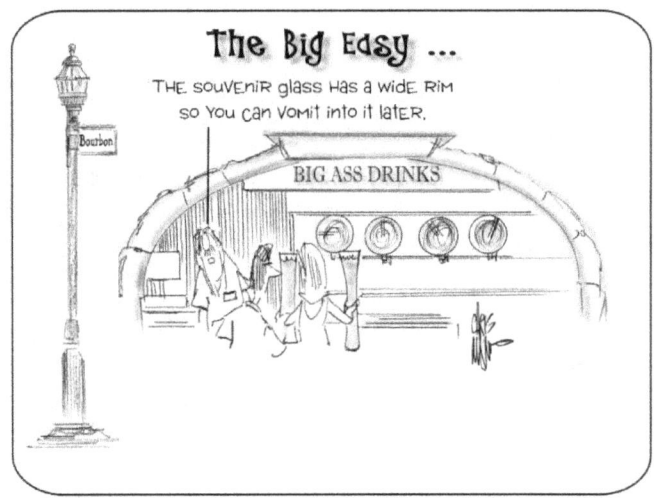
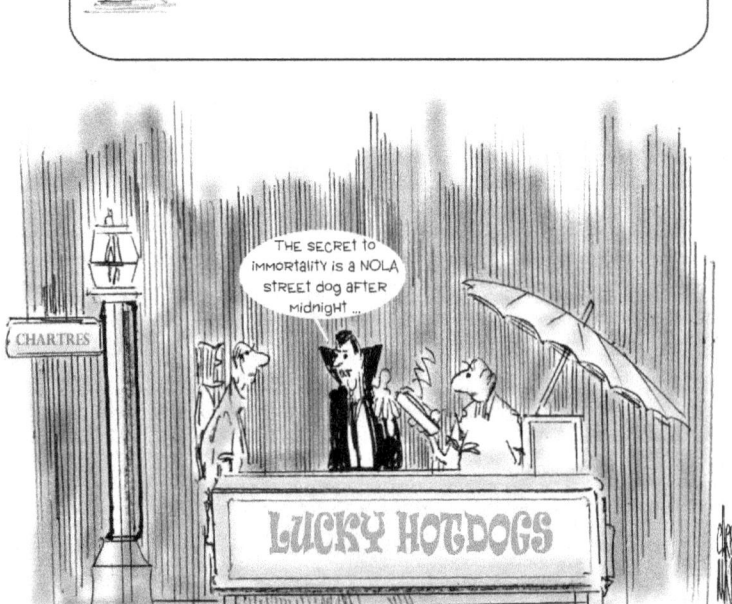
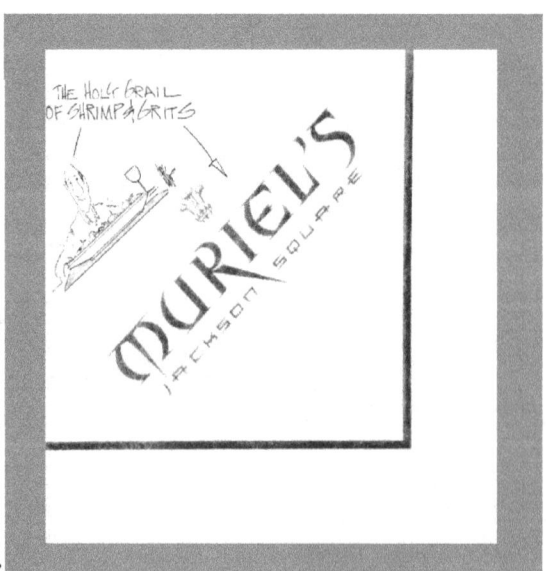

Cartoon REFUGE
Summer 2024

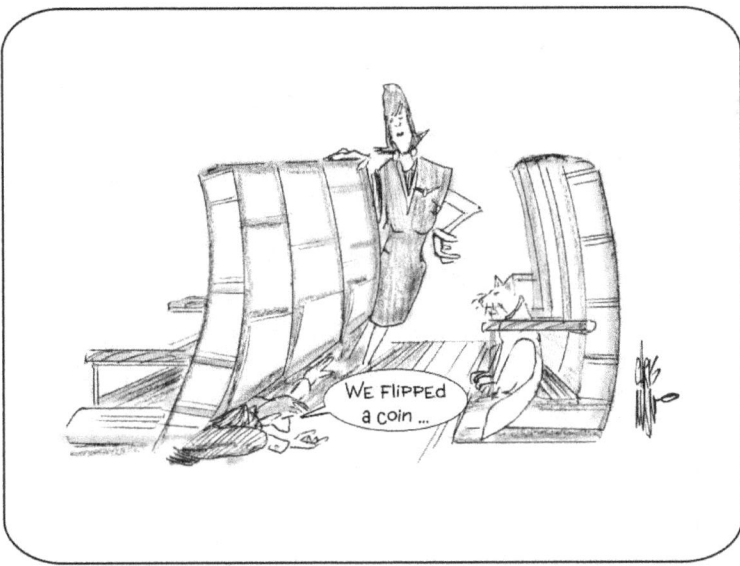

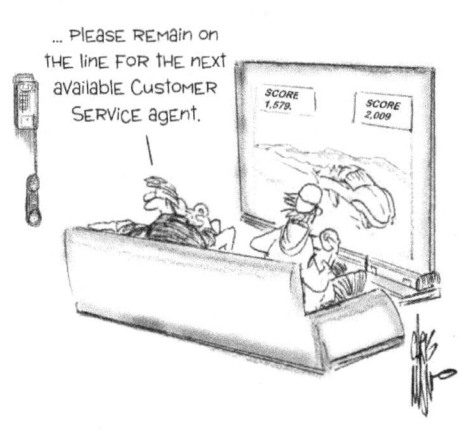

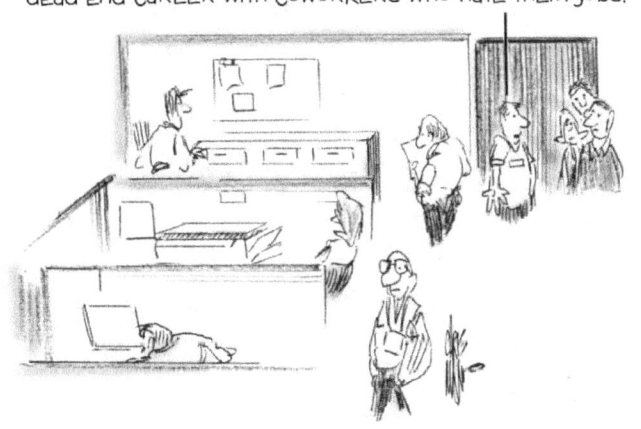

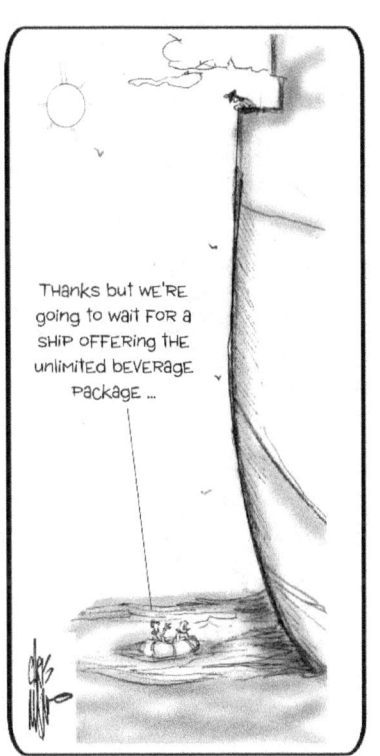

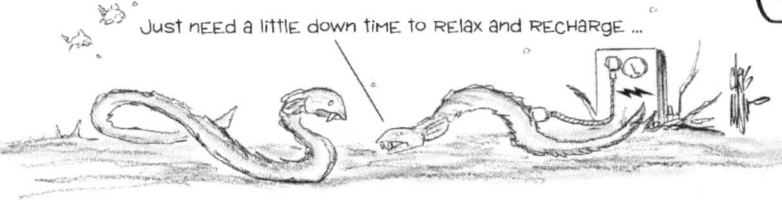

Cartoon REFUGE
Summer 2024

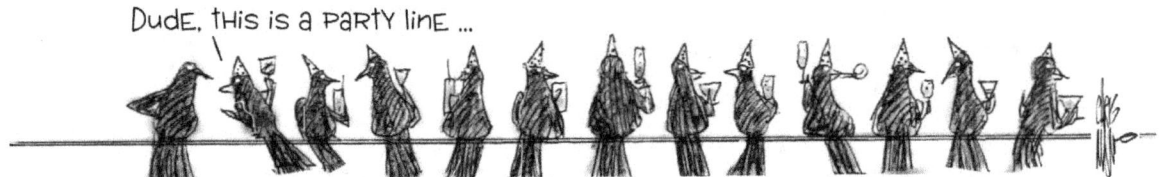

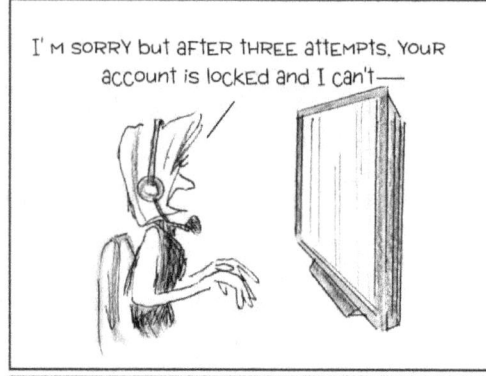

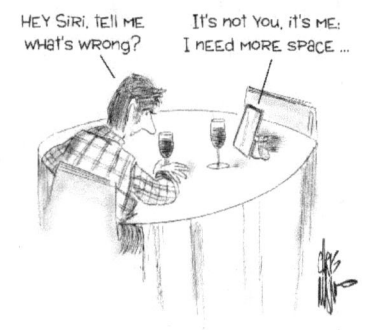

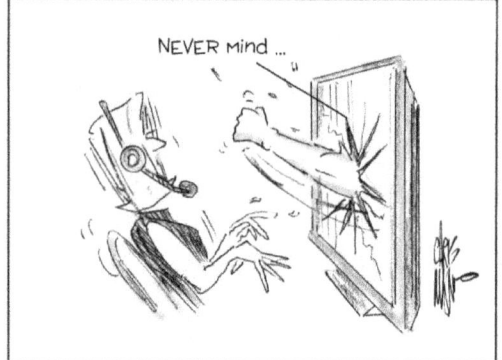

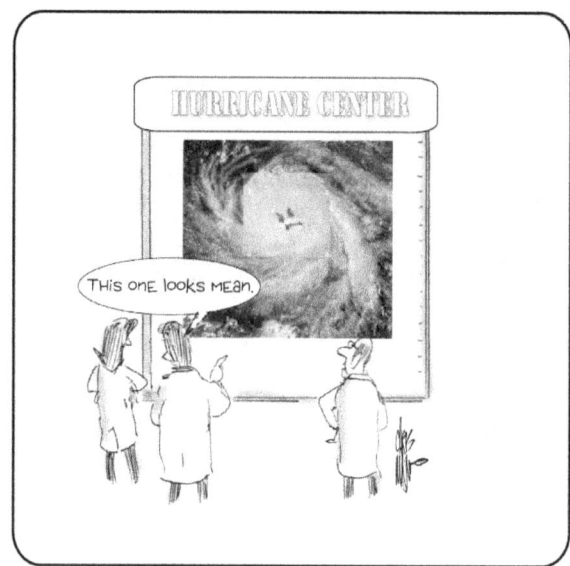

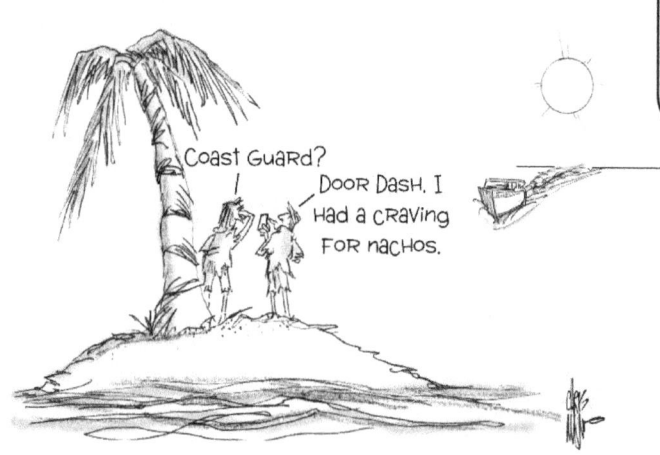

Cartoon REFUGE
Summer 2024

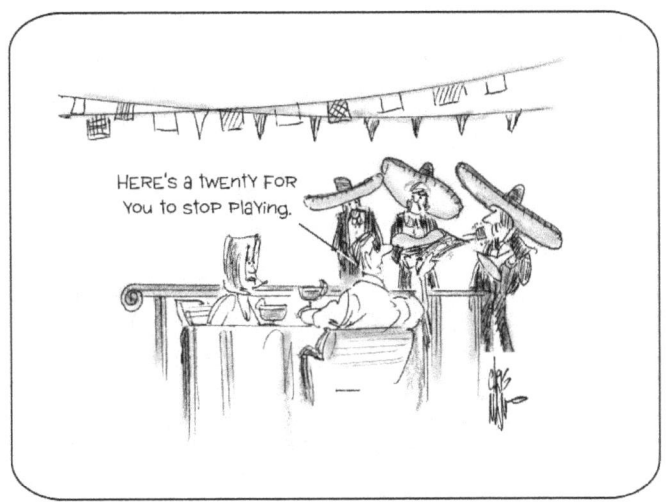

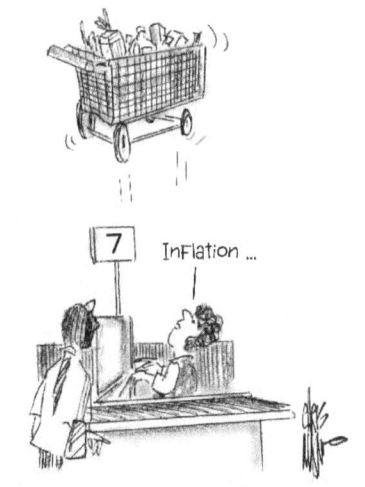

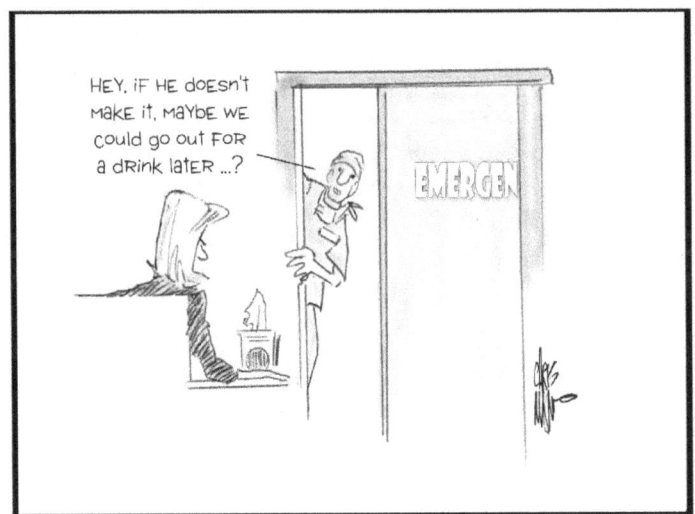

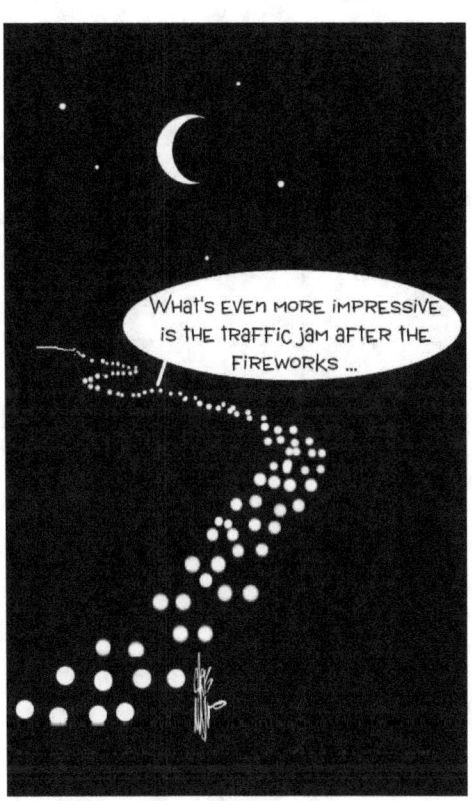

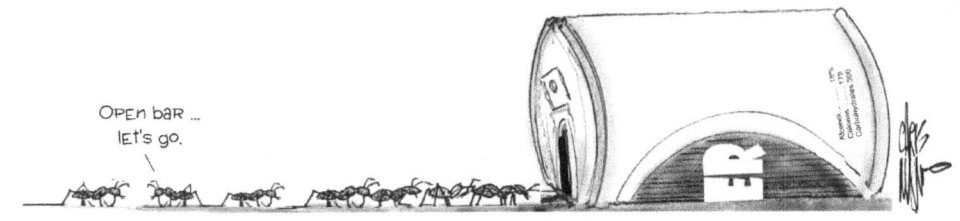

Cartoon REFUGE
Summer 2024

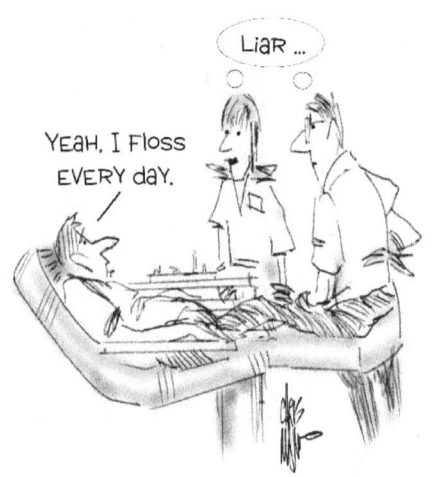

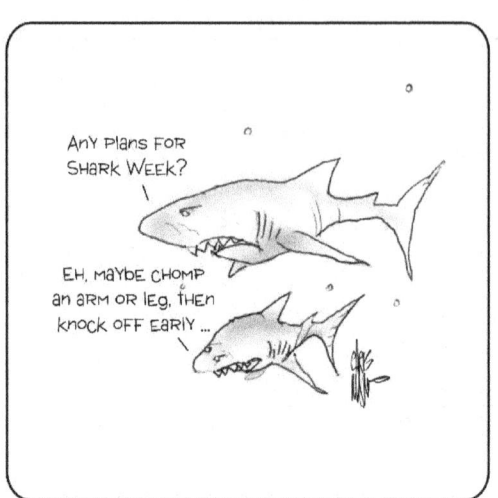

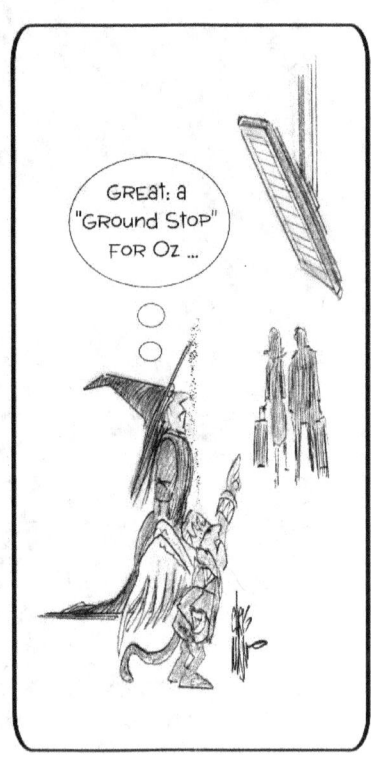

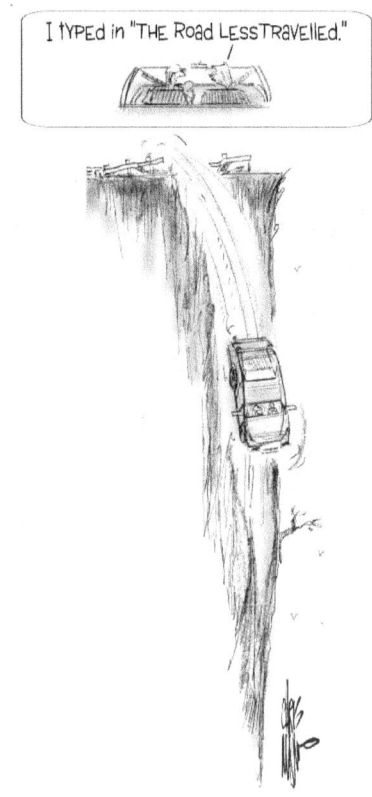

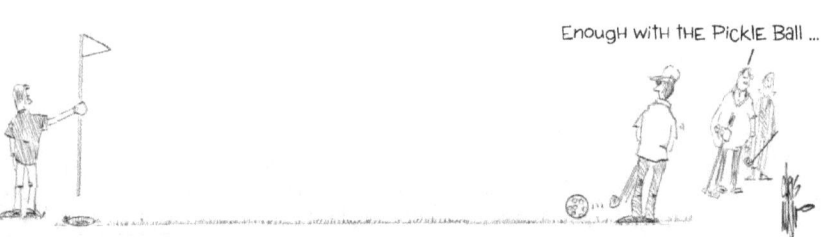

Cartoon REFUGE
Summer 2024

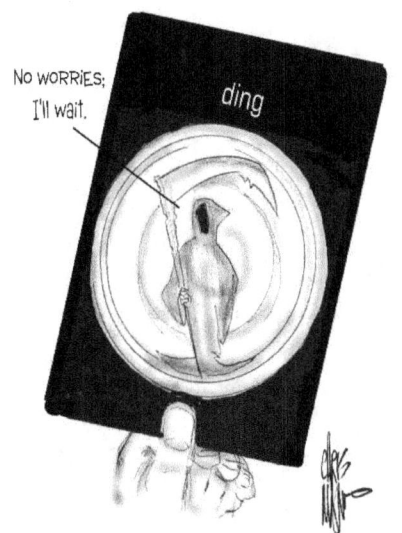

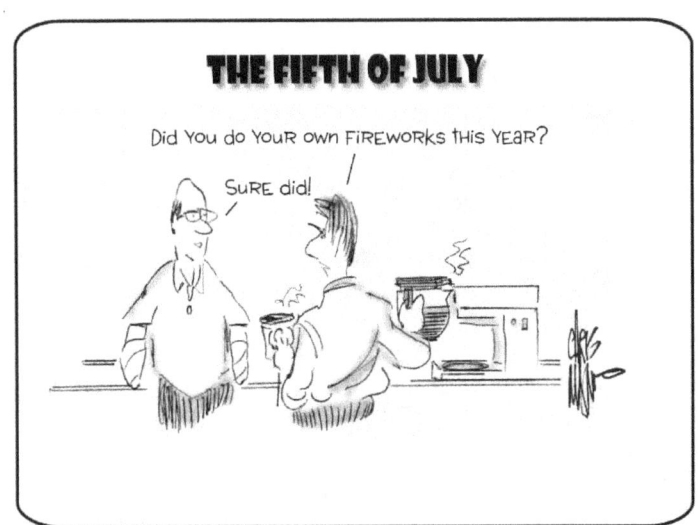

Kid World ...

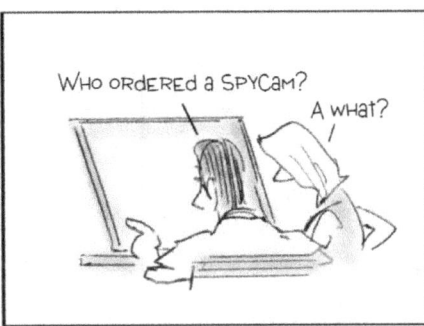

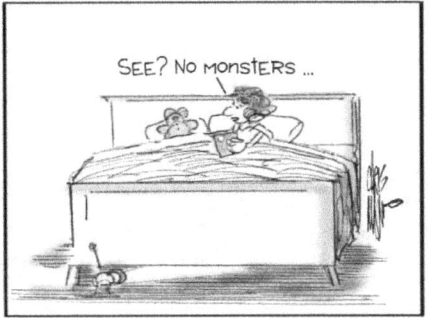

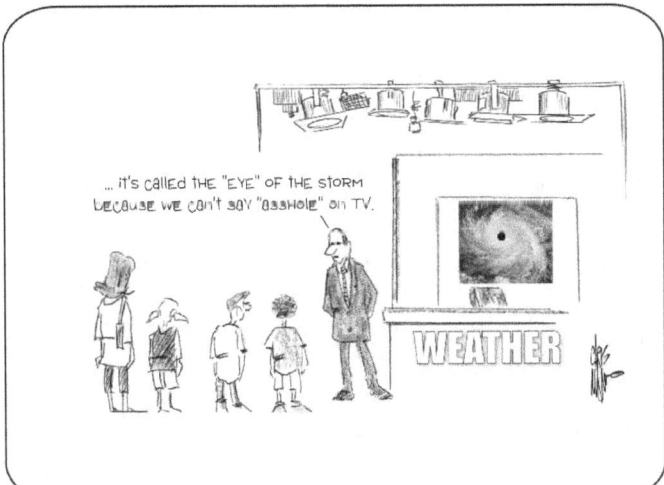

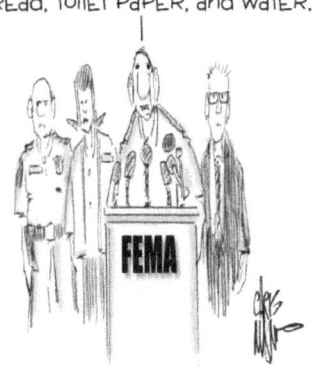

Cartoon REFUGE
Summer 2024

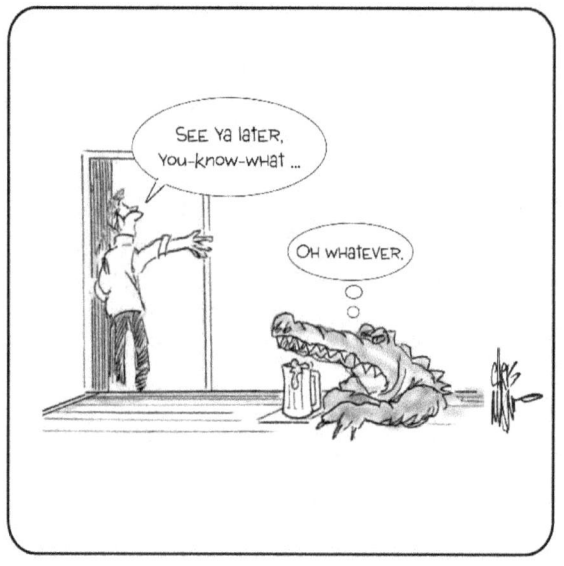

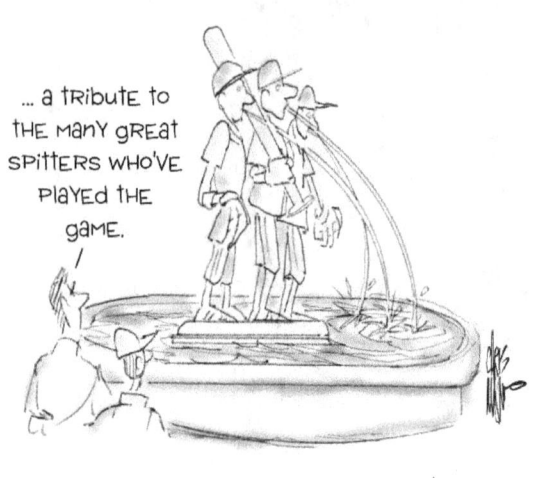

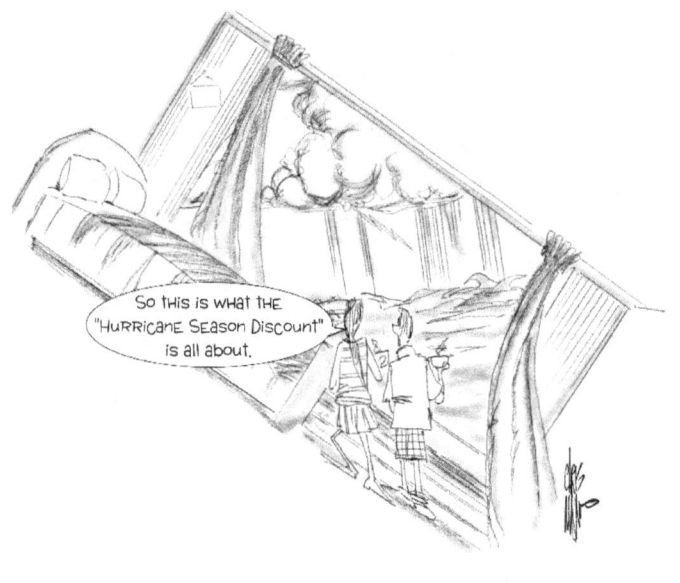

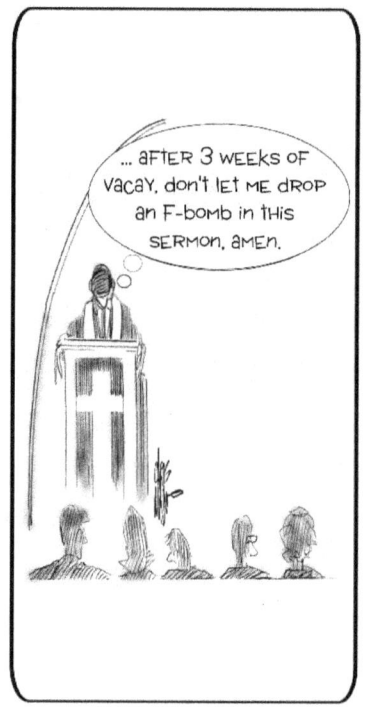

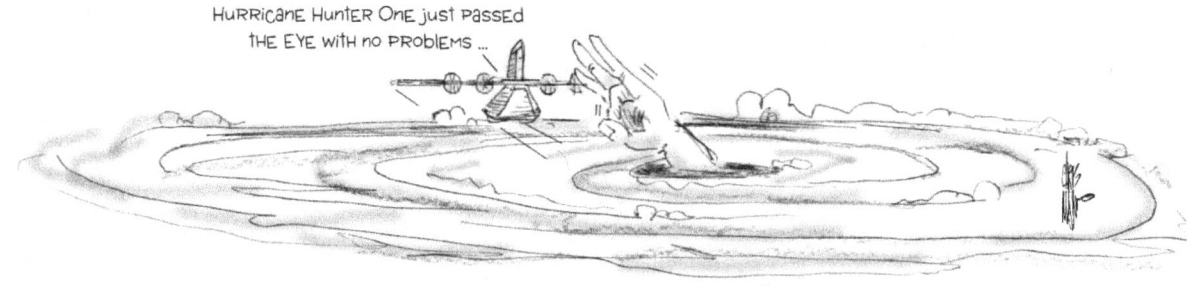

Cartoon REFUGE
Summer 2024

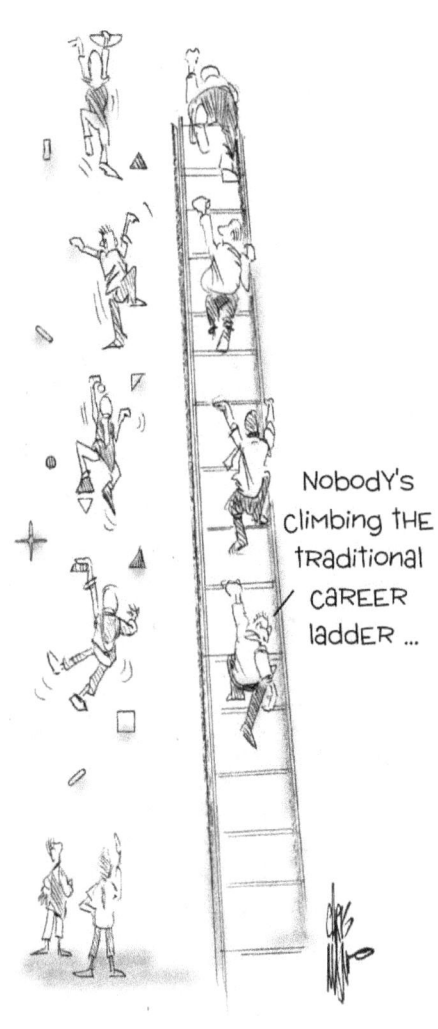

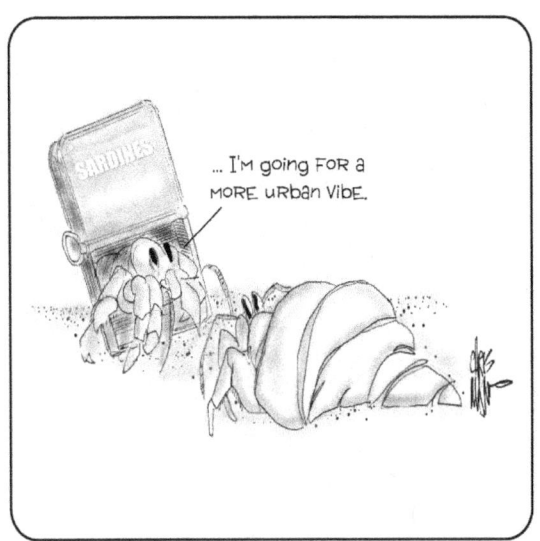

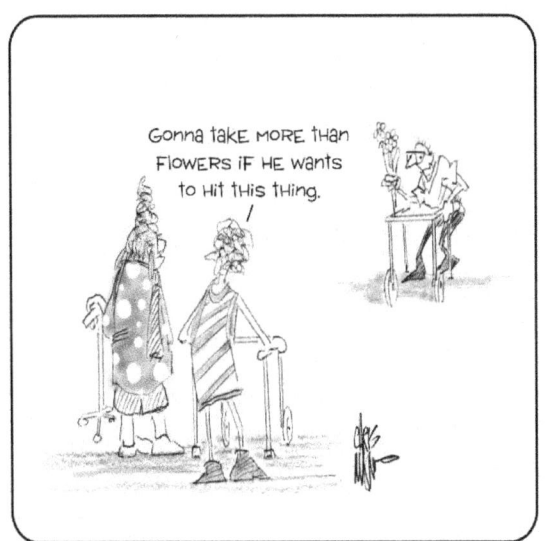

Open Seating Strategy

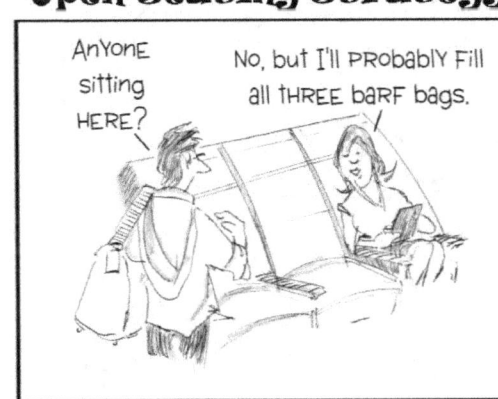

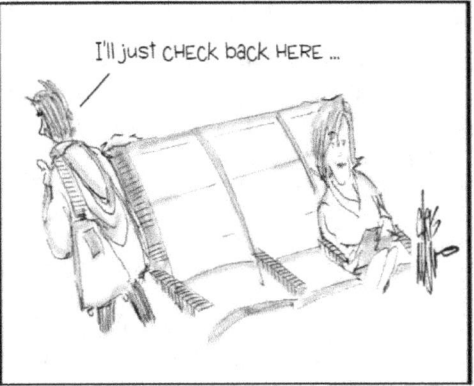

Cartoon REFUGE
Summer 2024

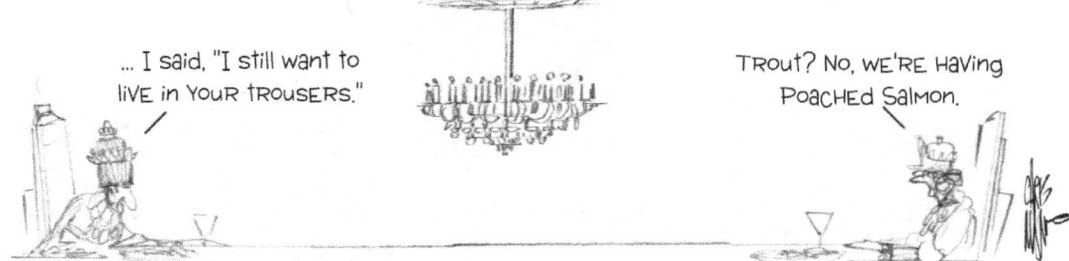

Cartoon REFUGE
Summer 2024

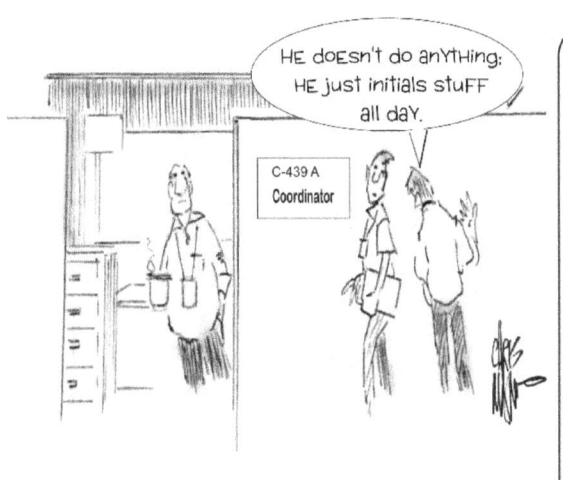

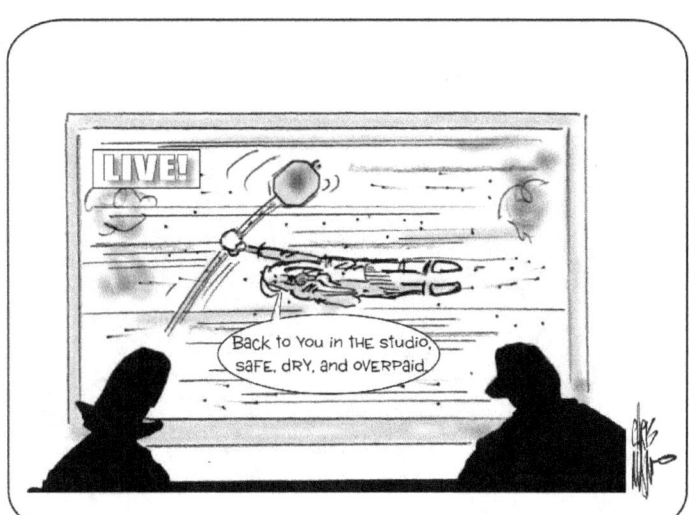

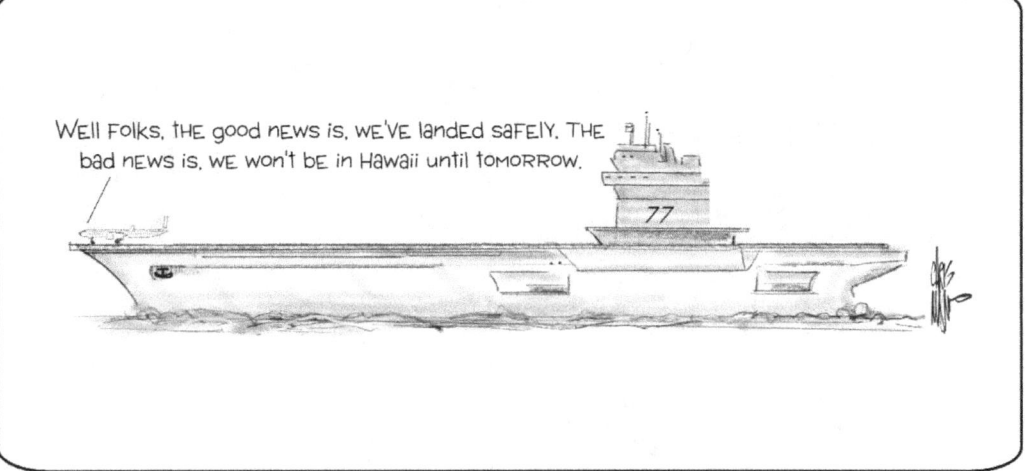

Pope Joe the Grateful.

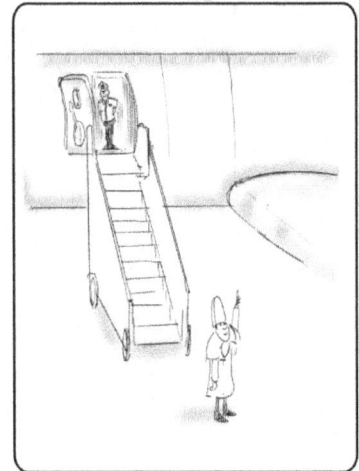
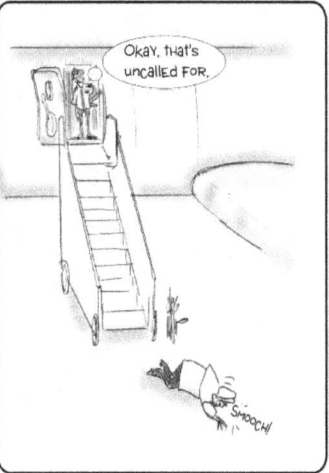

Cartoon REFUGE
Summer 2024

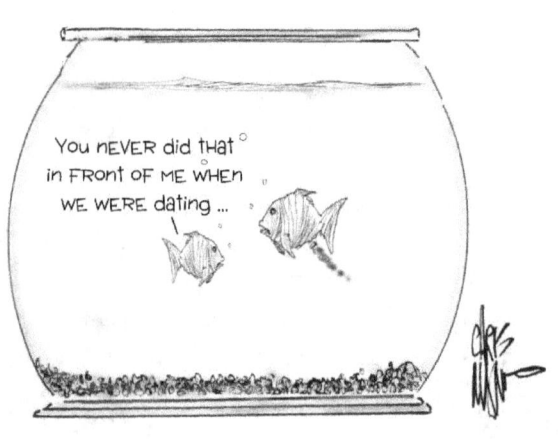
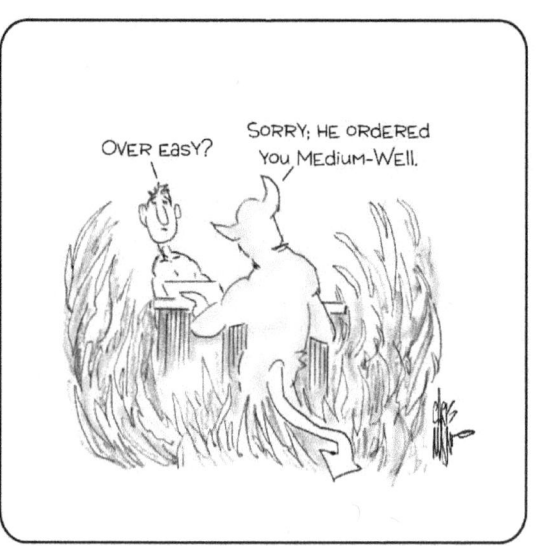
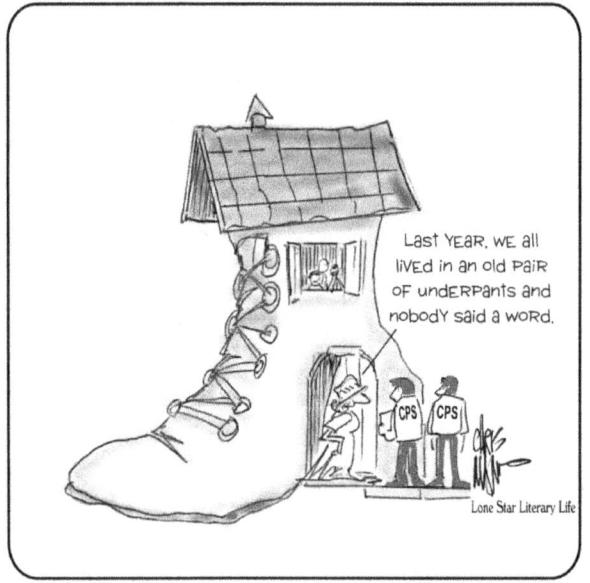
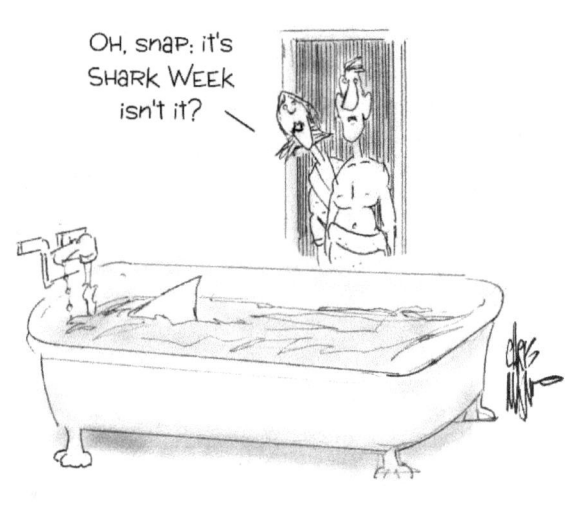
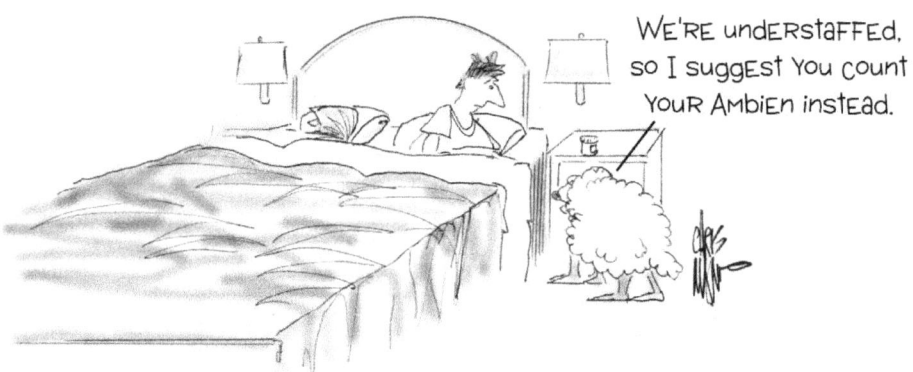

Cartoon REFUGE
Summer 2024

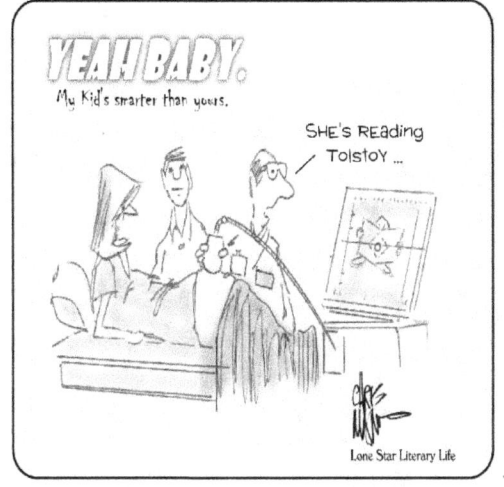

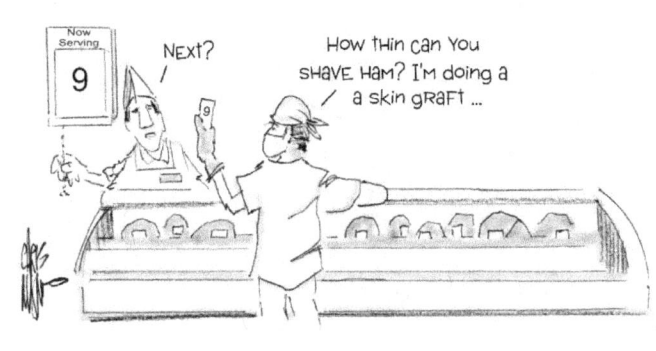

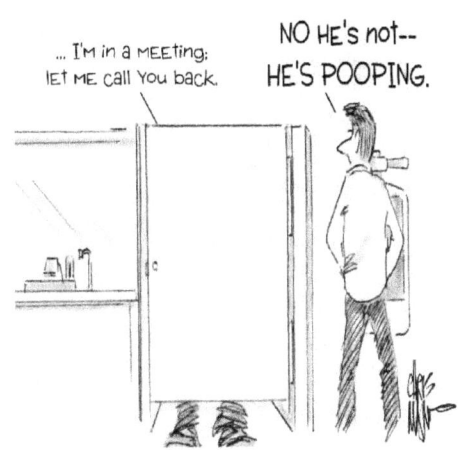

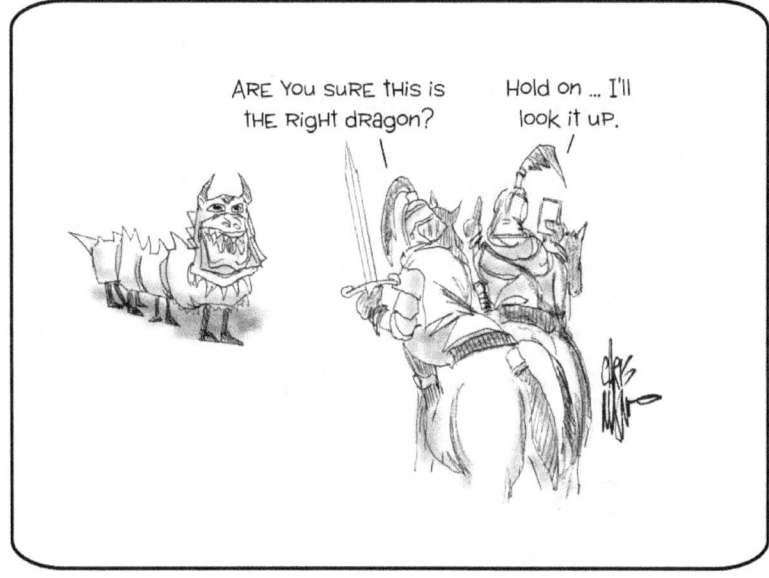

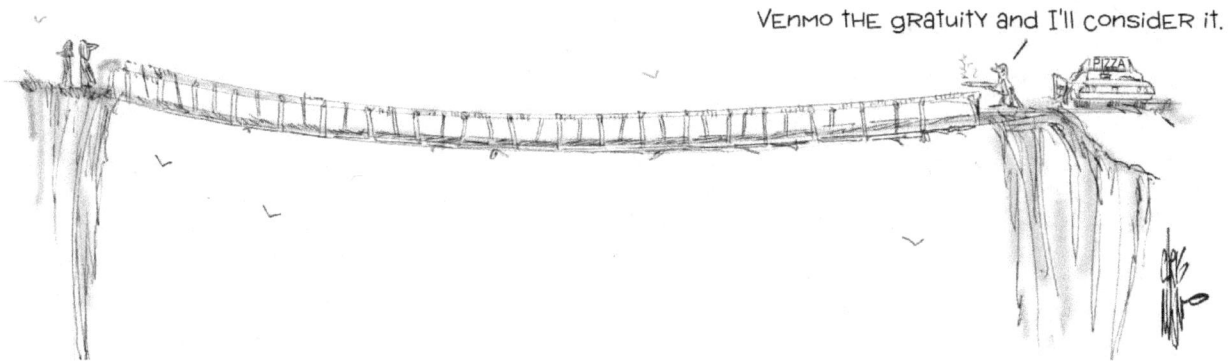

Cartoon REFUGE
Summer 2024

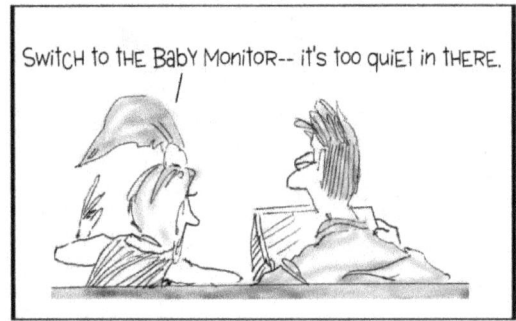

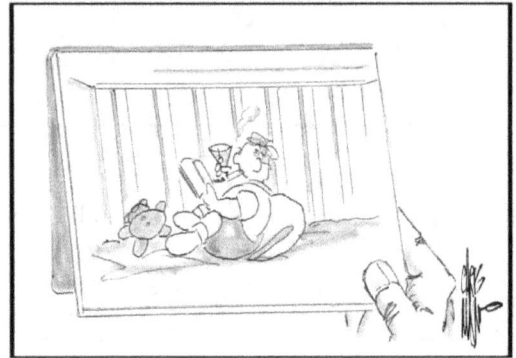

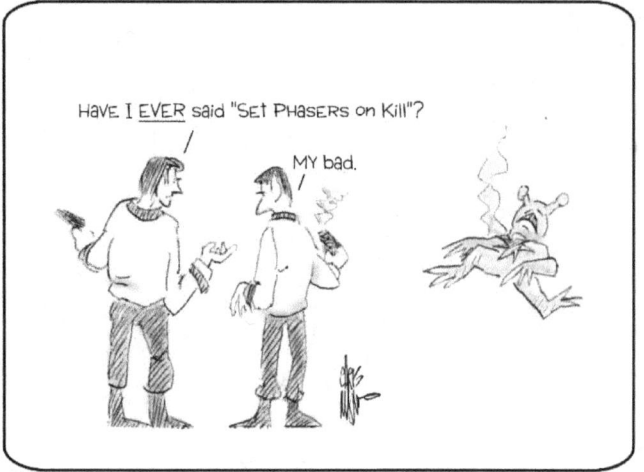

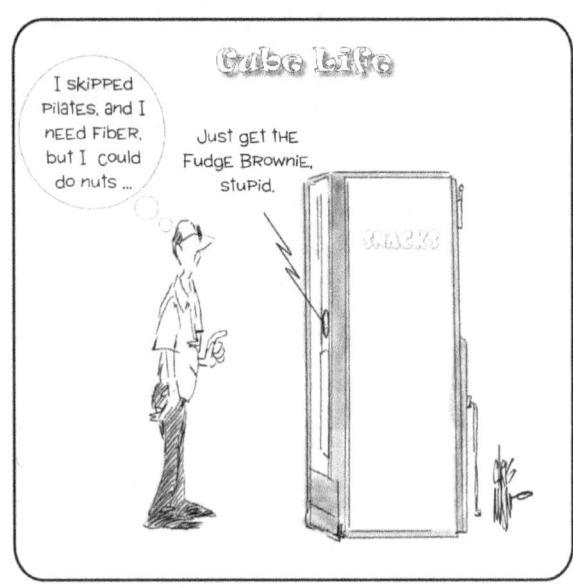

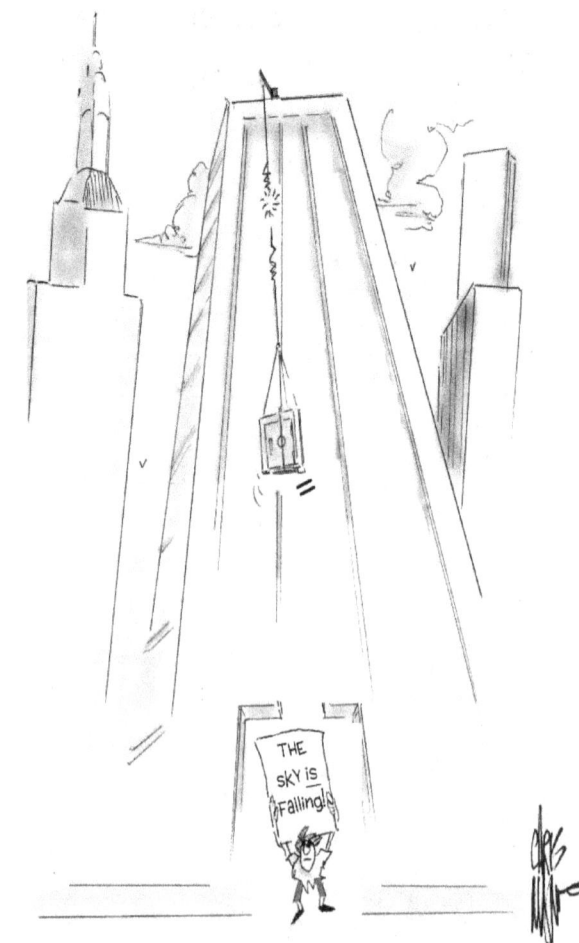

Cartoon REFUGE
Summer 2024

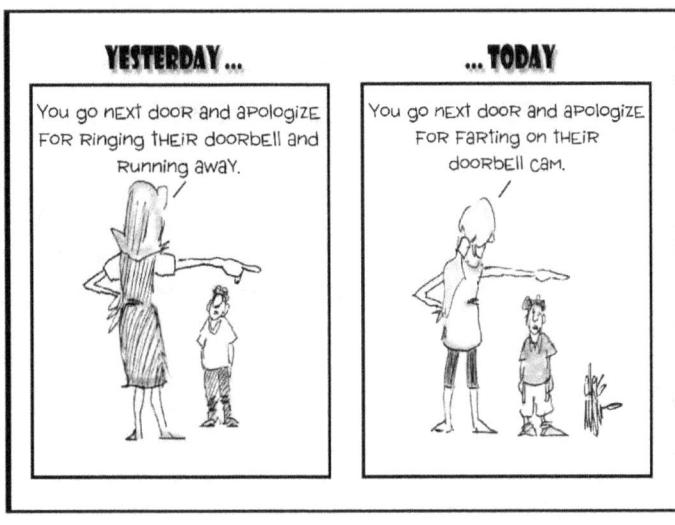

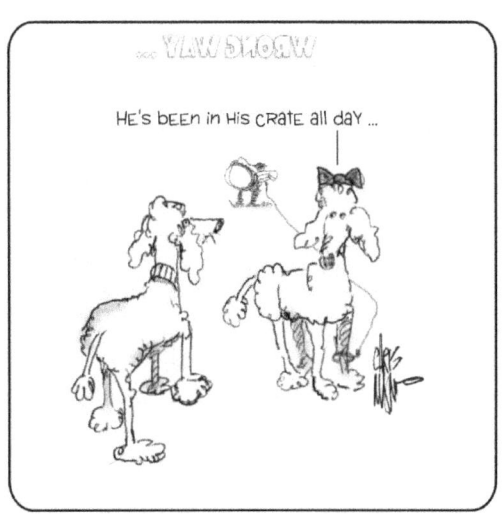

Gulliver's Travails

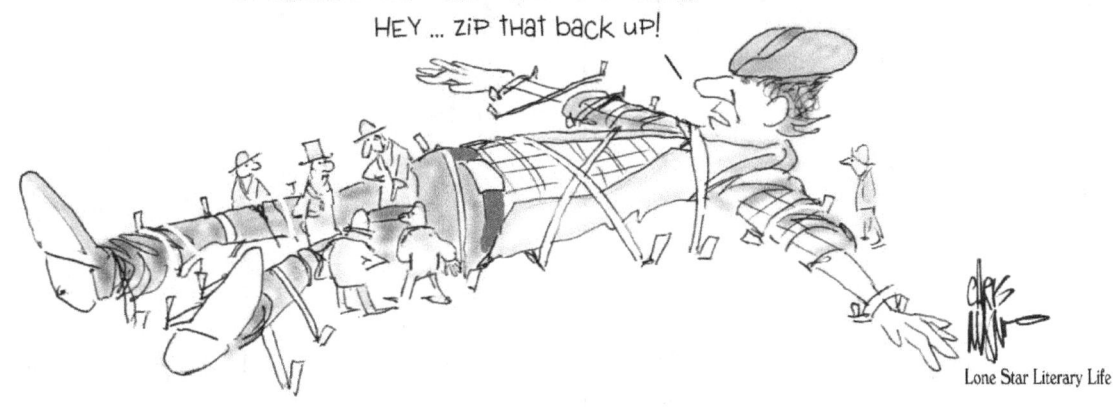

Lone Star Literary Life

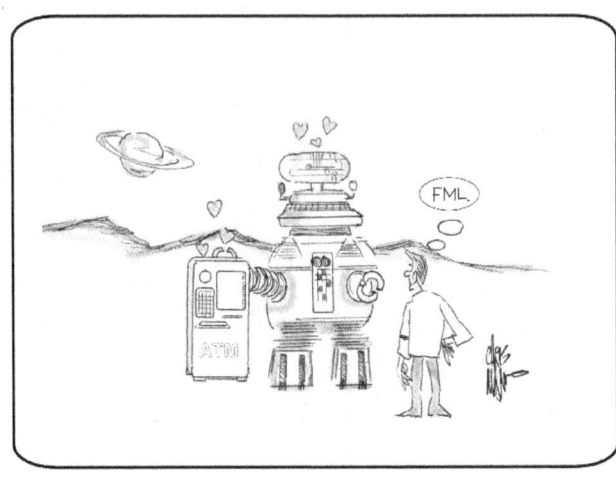

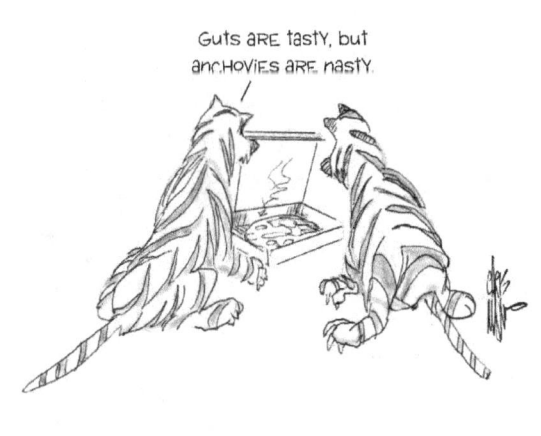

Cartoon REFUGE
Summer 2024

Cartoon REFUGE
Summer 2024

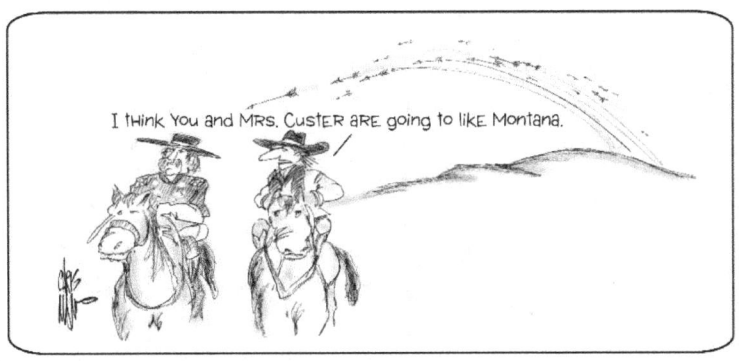

Attila the Hung

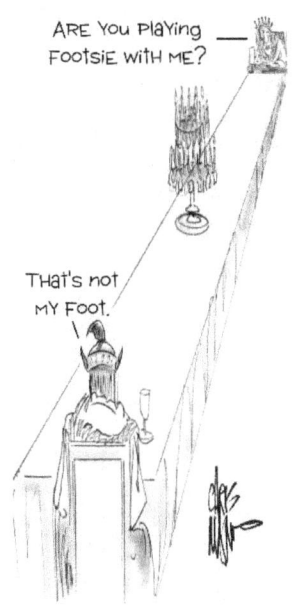

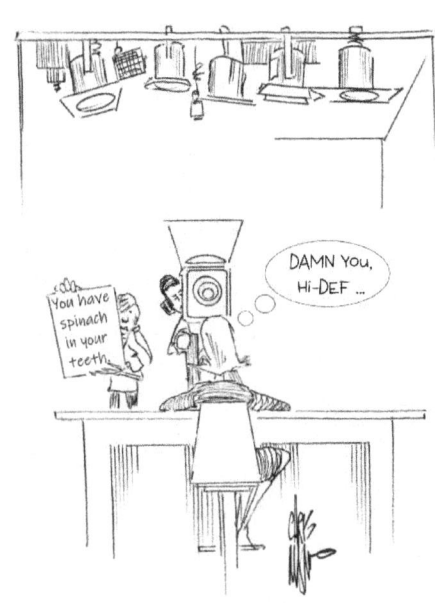

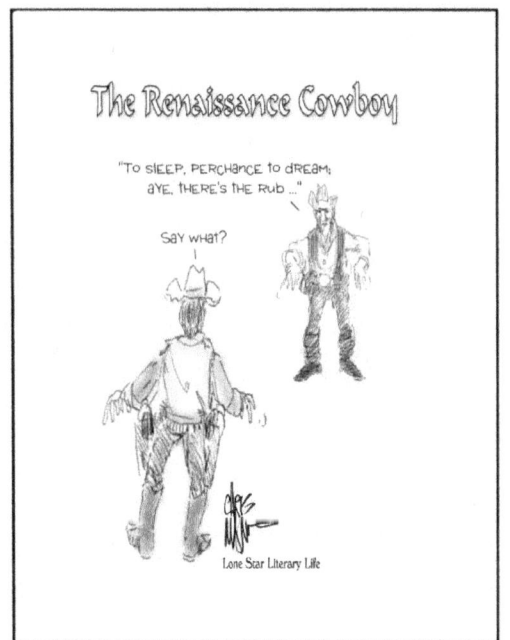

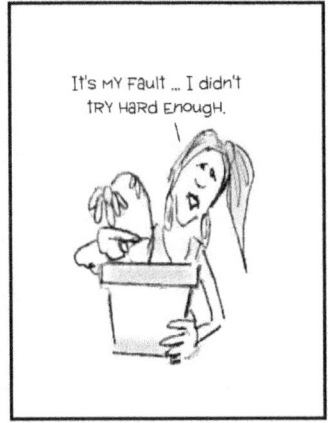
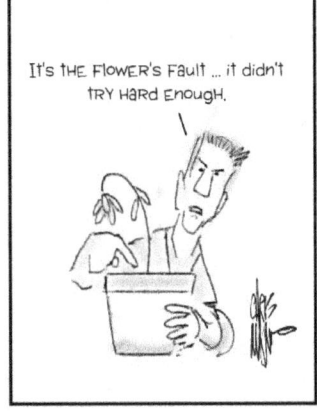

Cartoon REFUGE
Summer 2024

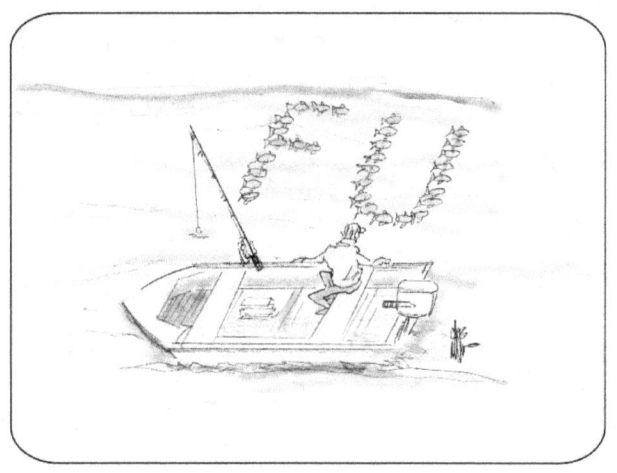

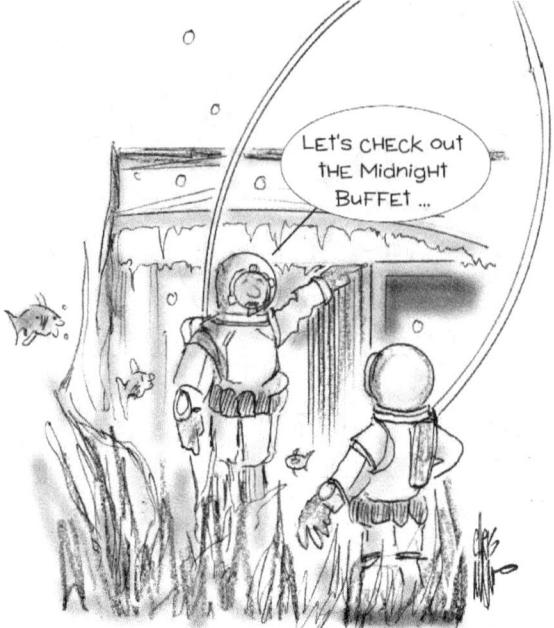

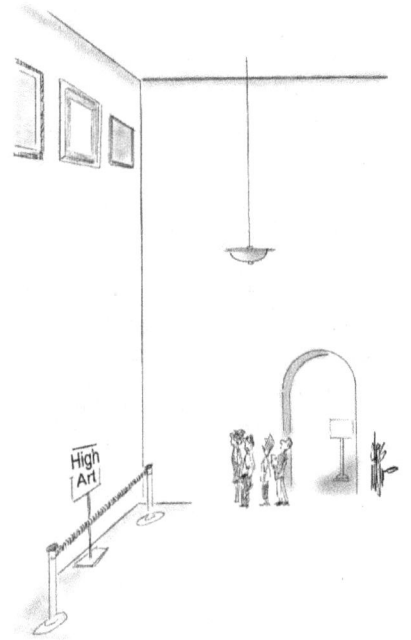

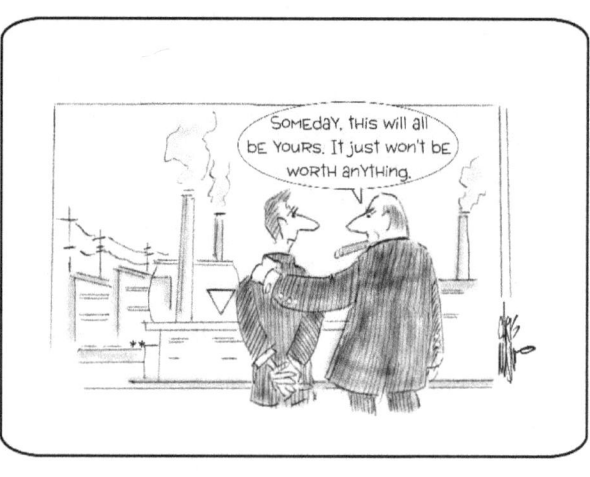

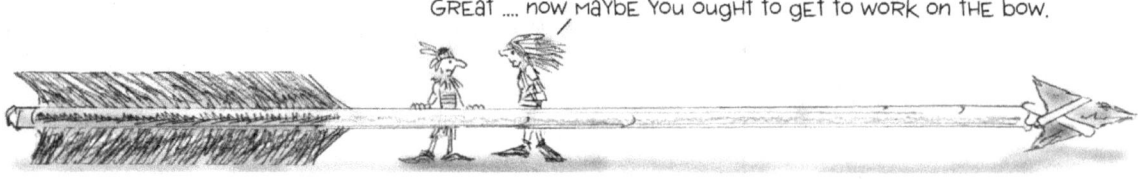

Cartoon REFUGE
Summer 2024

Knight Light

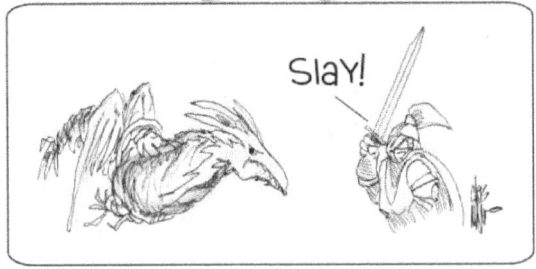

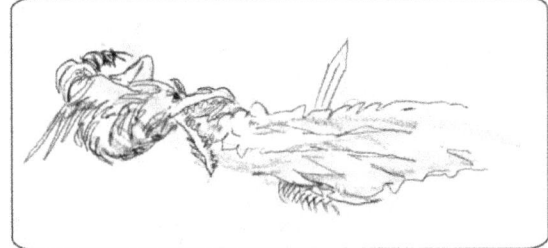

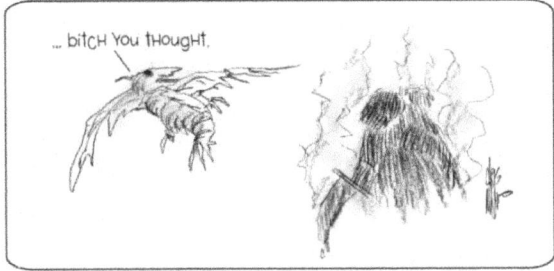

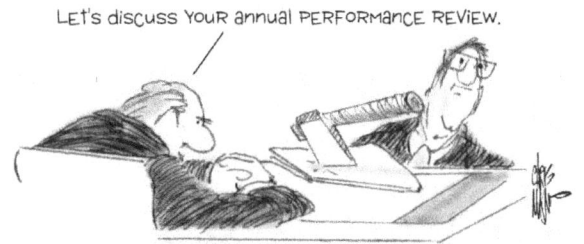

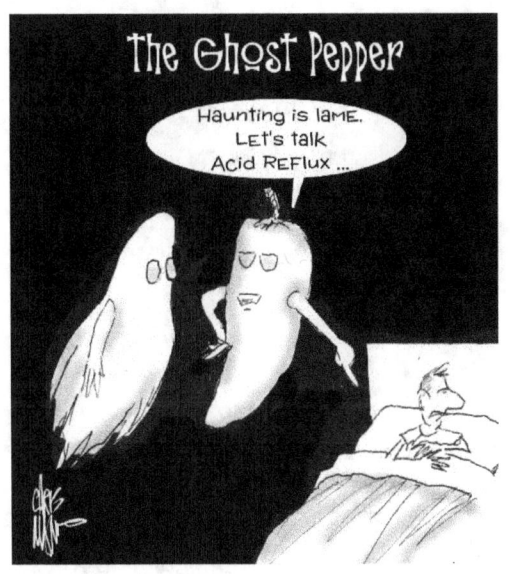

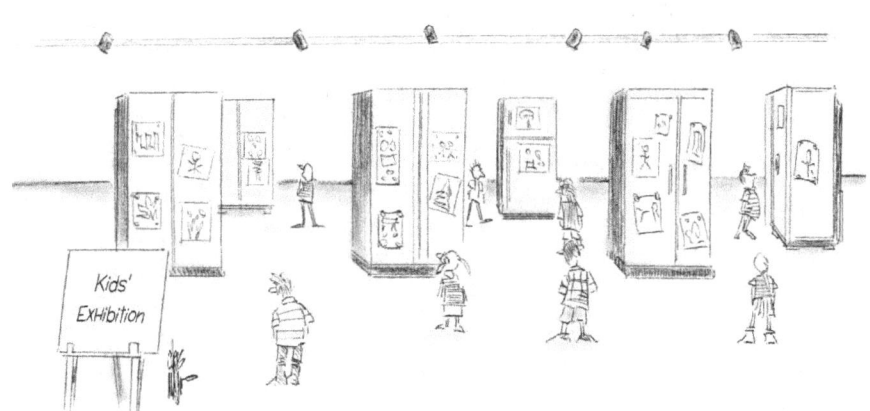

Cartoon REFUGE
Summer 2024

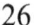

Cartoon REFUGE
Summer 2024

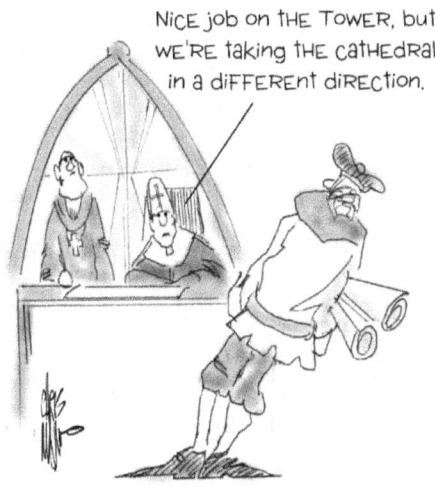
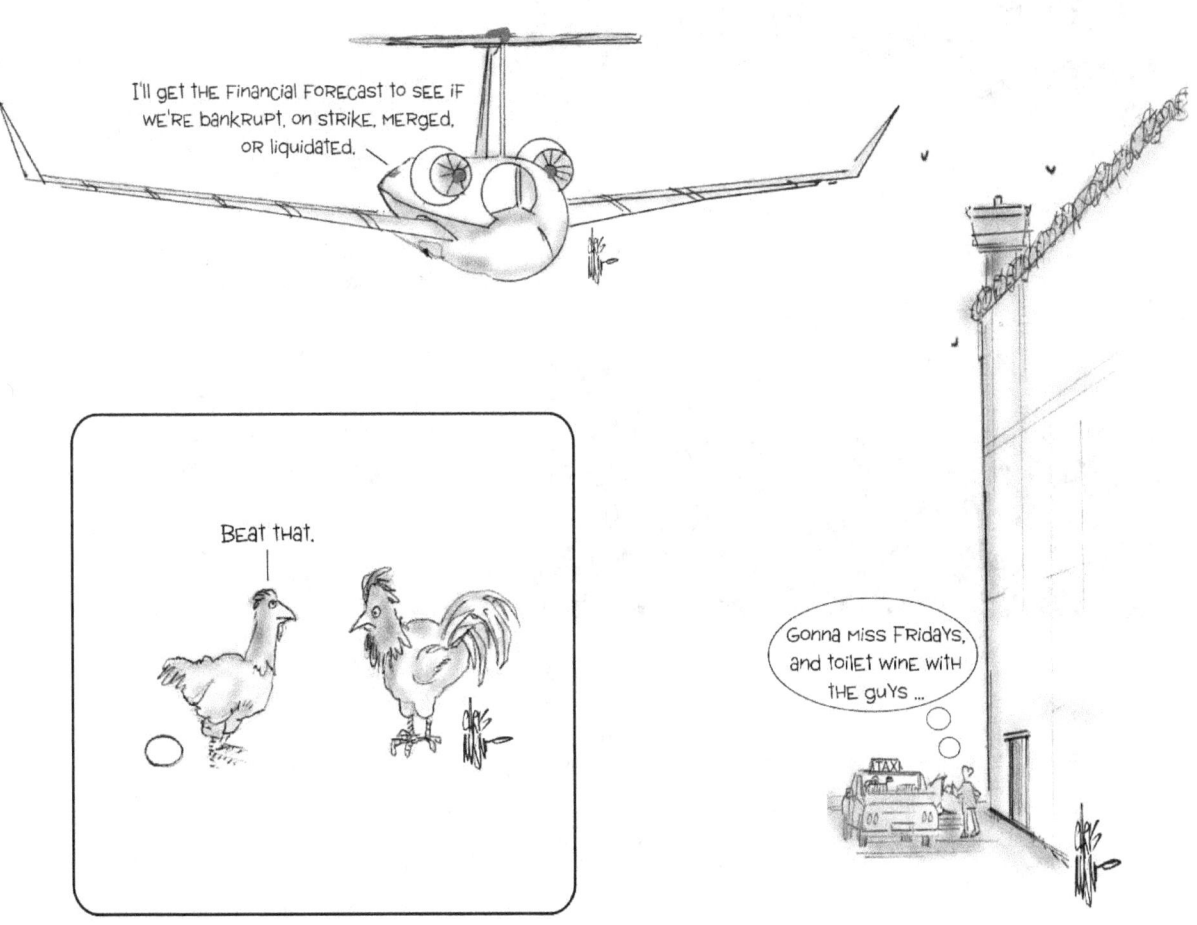

Cartoon REFUGE
Summer 2024

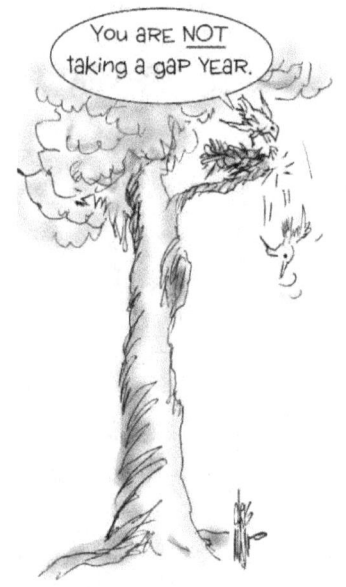

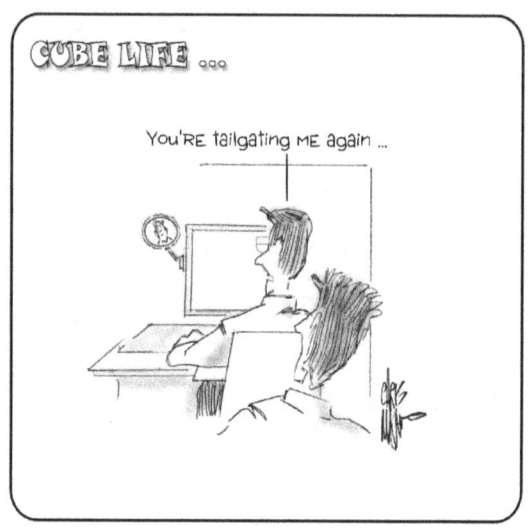

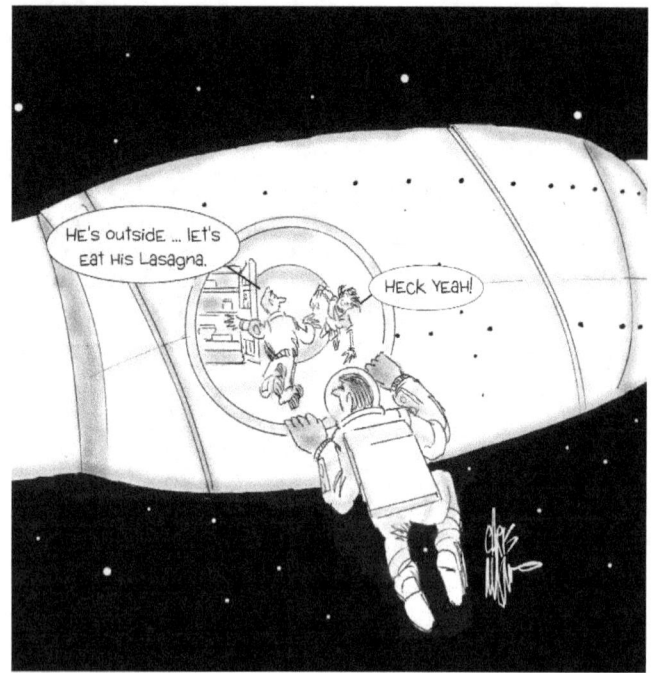

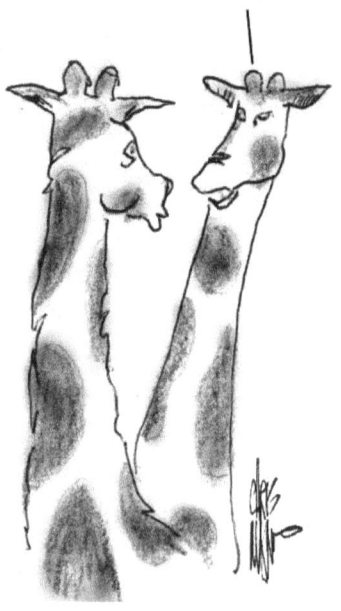

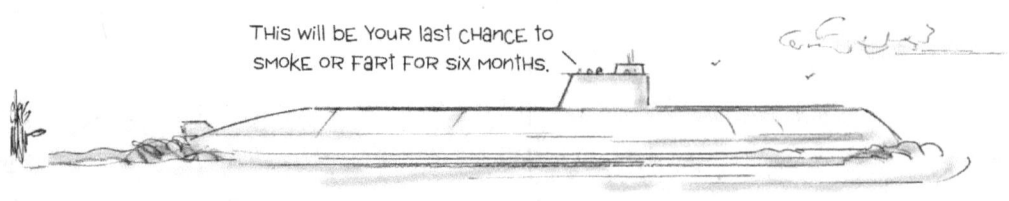

Cartoon REFUGE
Summer 2024

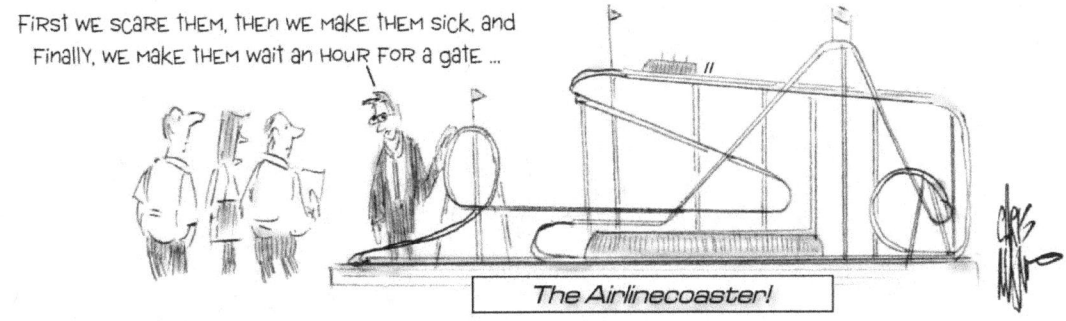

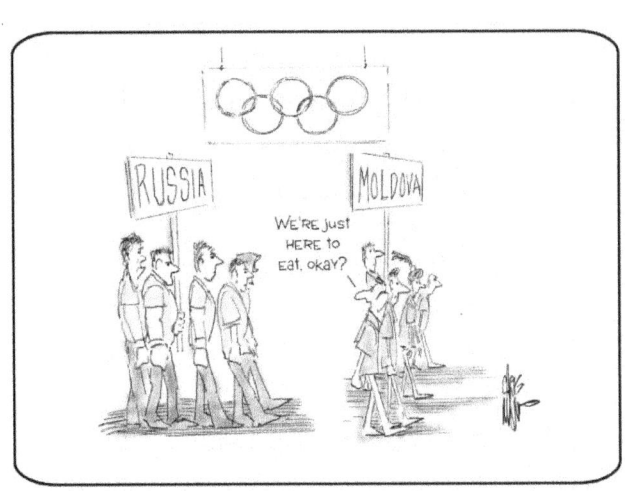

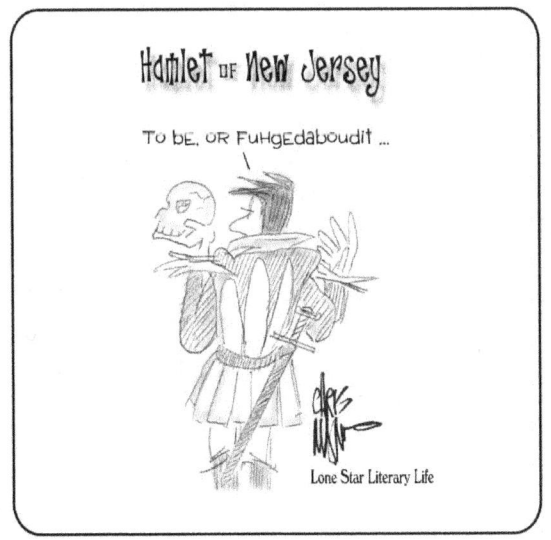

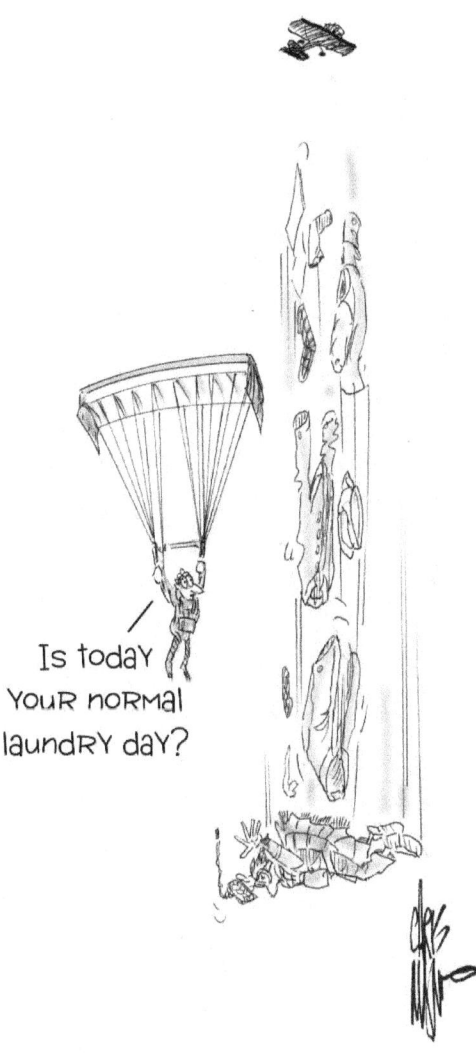

Cartoon REFUGE
Summer 2024

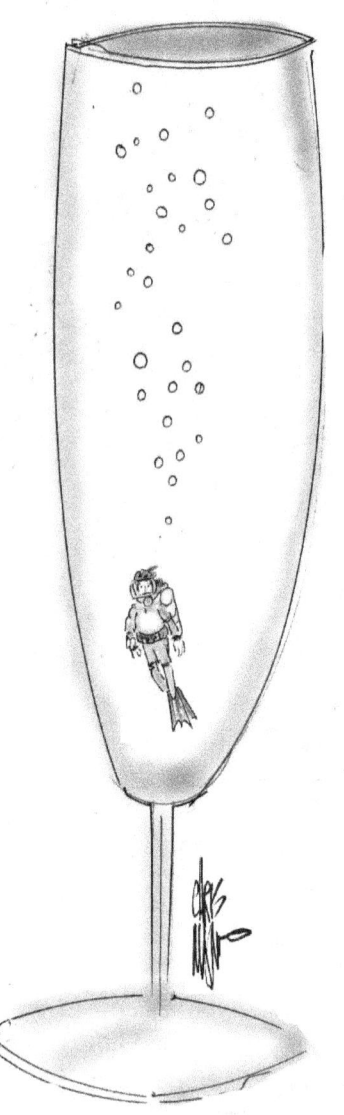

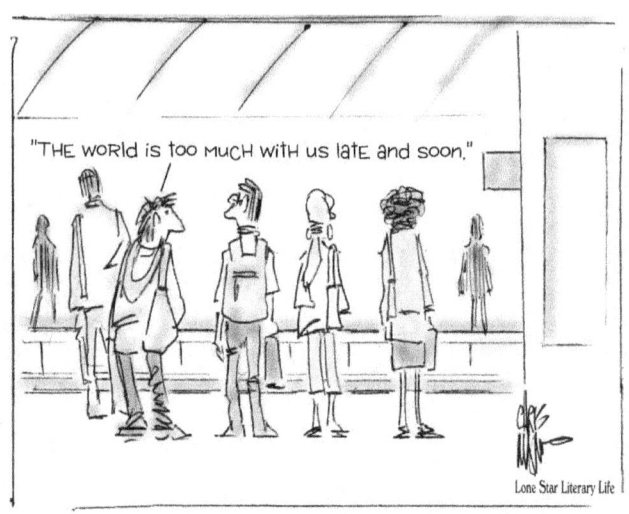

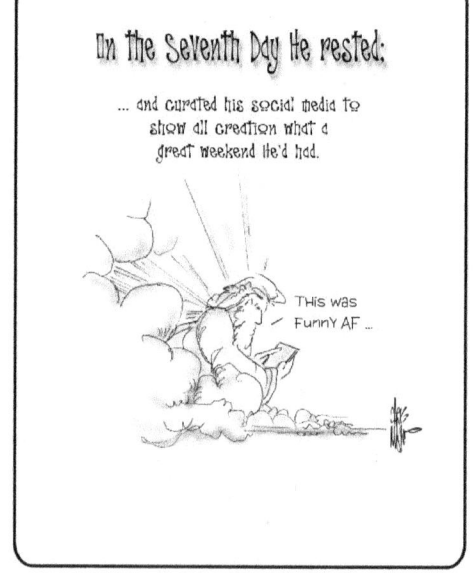

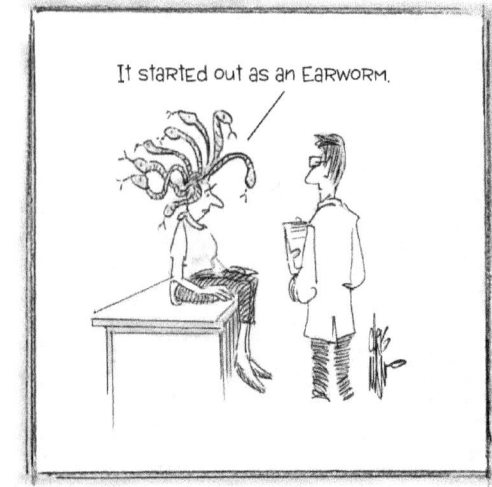

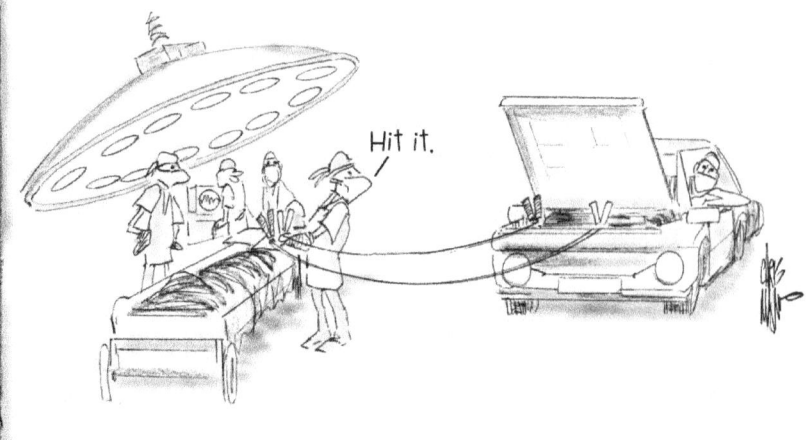

Cartoon REFUGE
Summer 2024

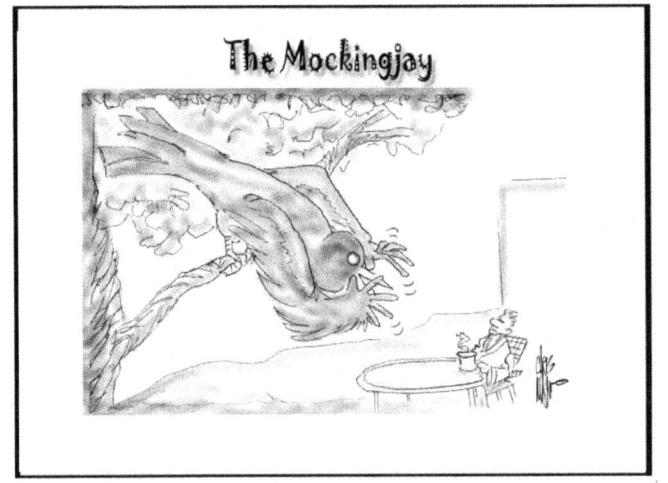

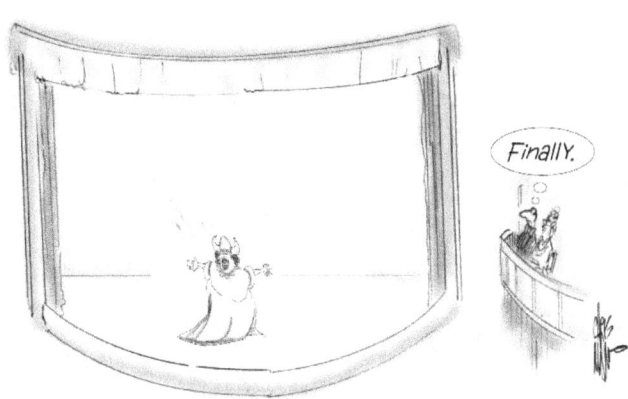

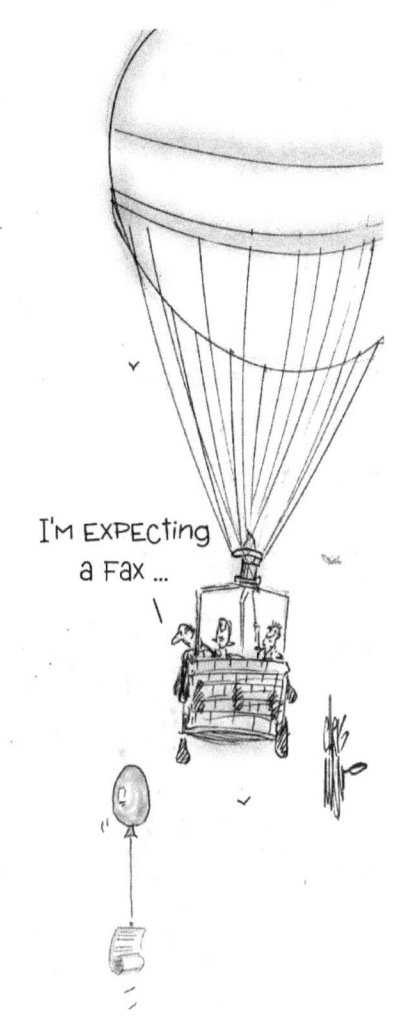

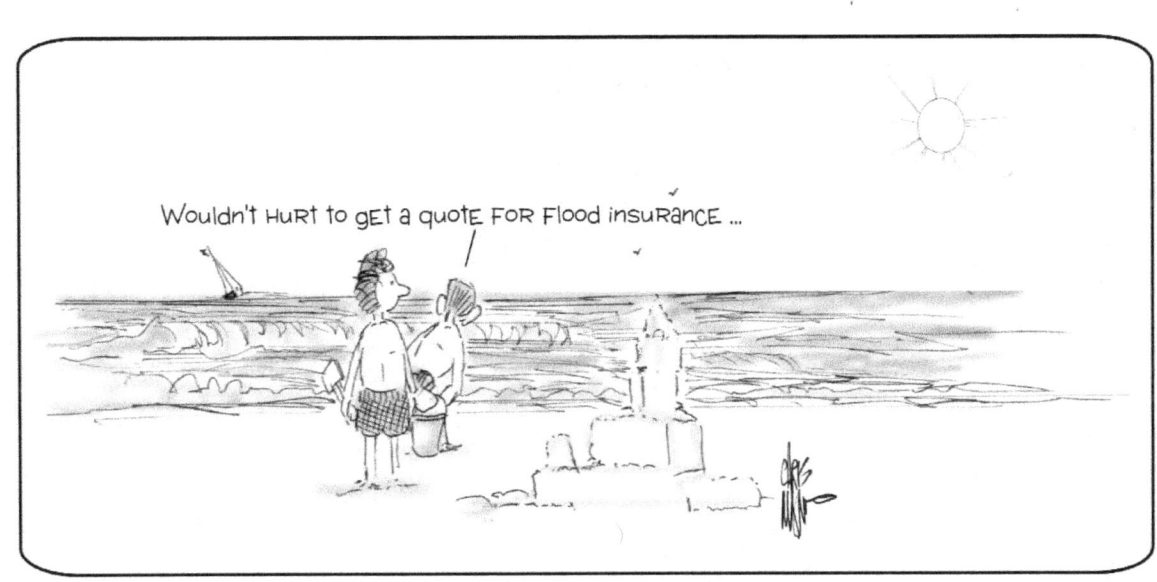

Cartoon REFUGE
Summer 2024

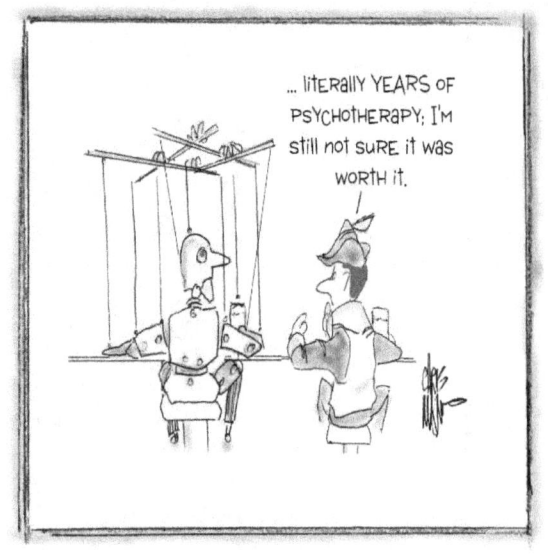

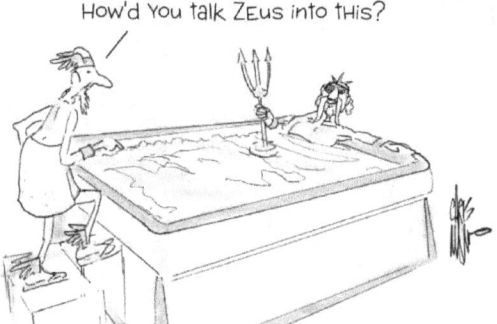

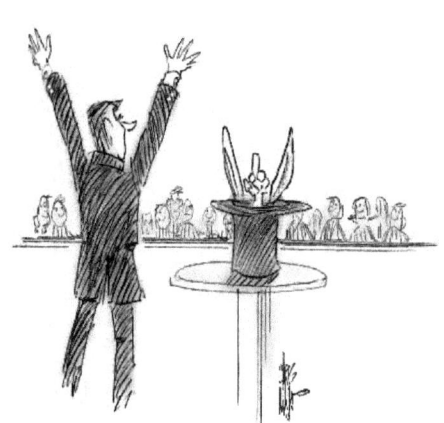

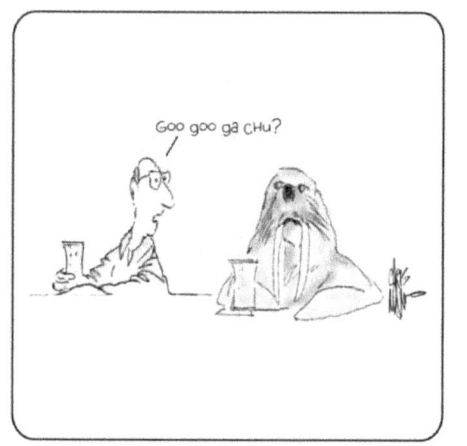

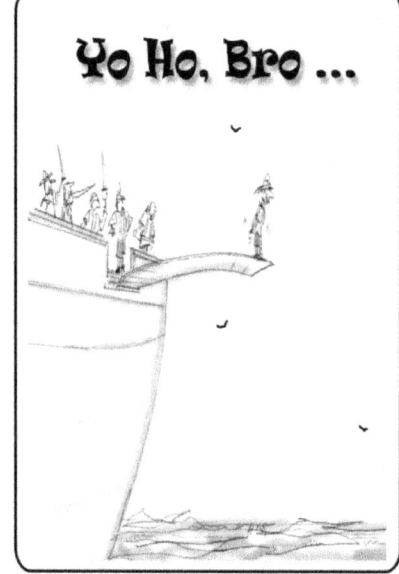

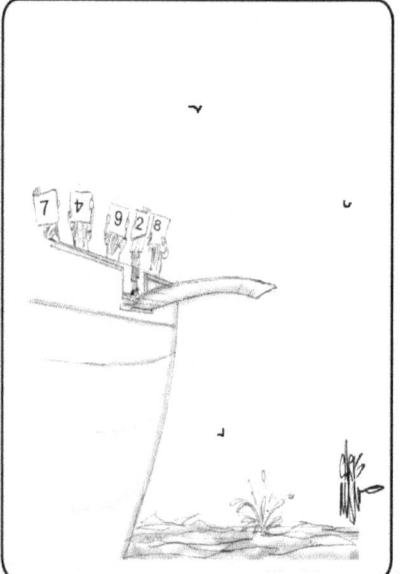

Cartoon REFUGE
Summer 2024

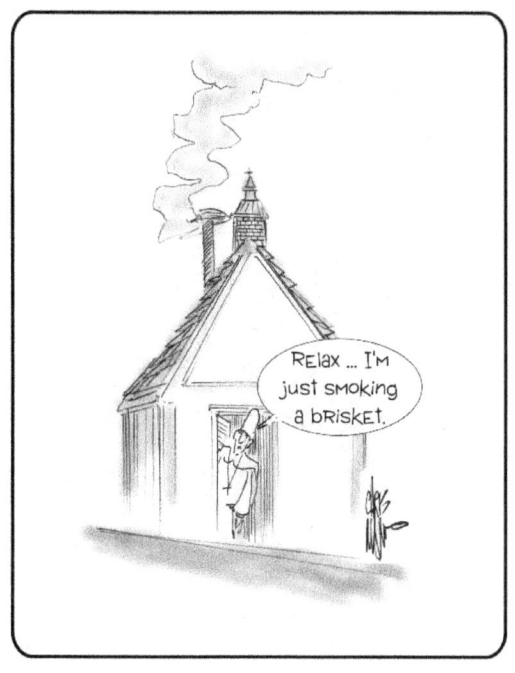

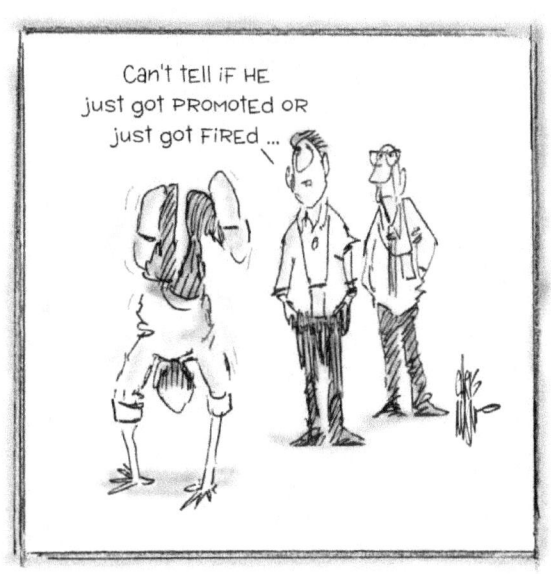

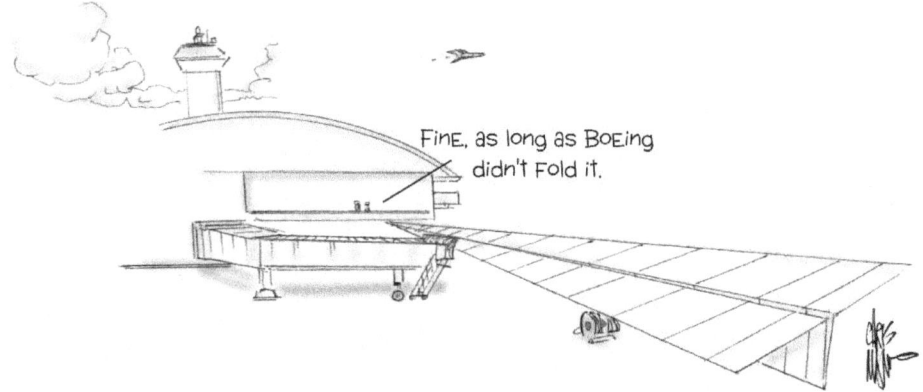

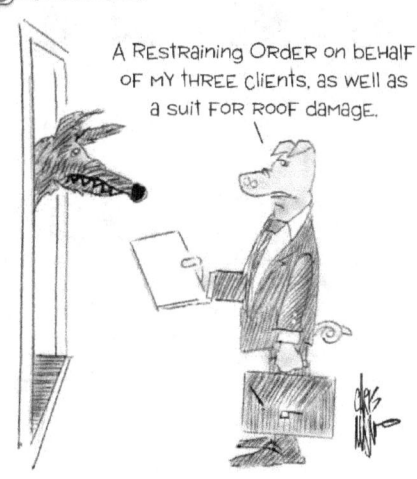

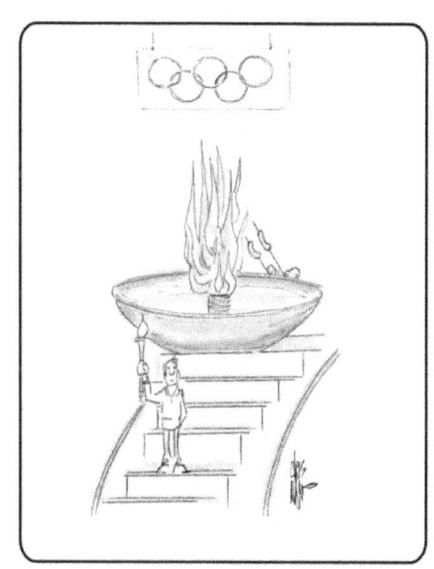

Cartoon REFUGE
Summer 2024

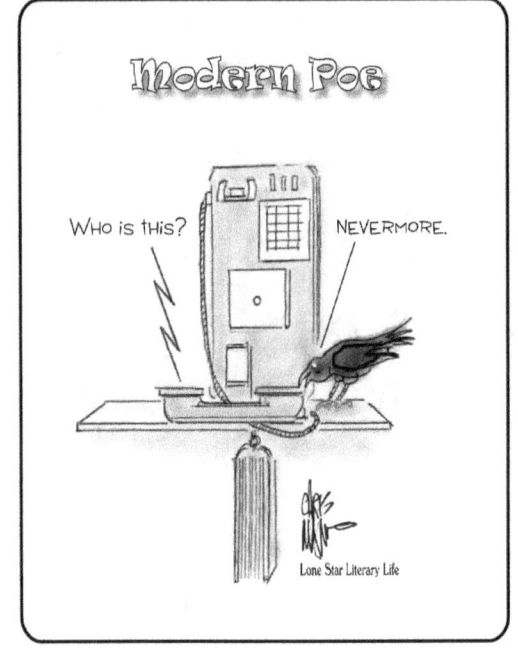

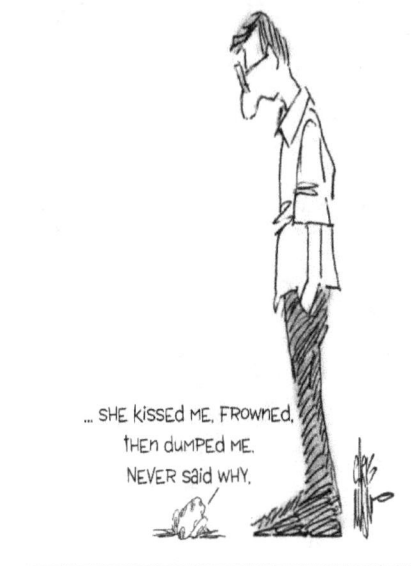

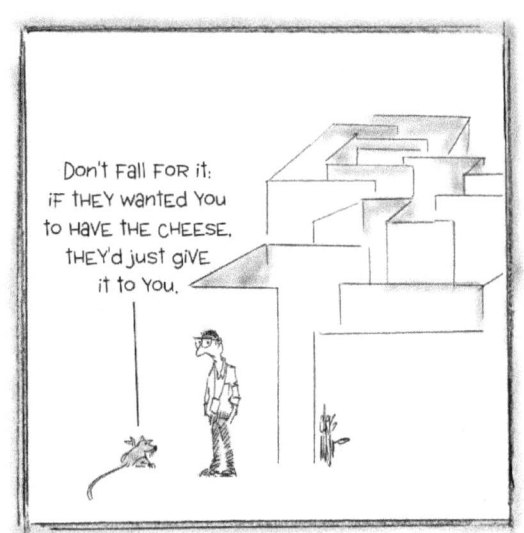

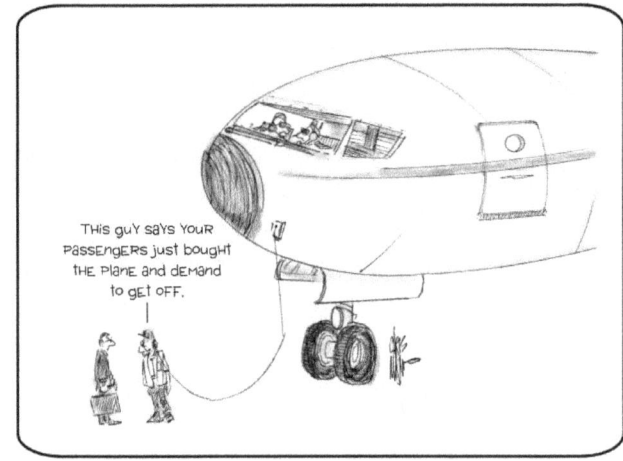

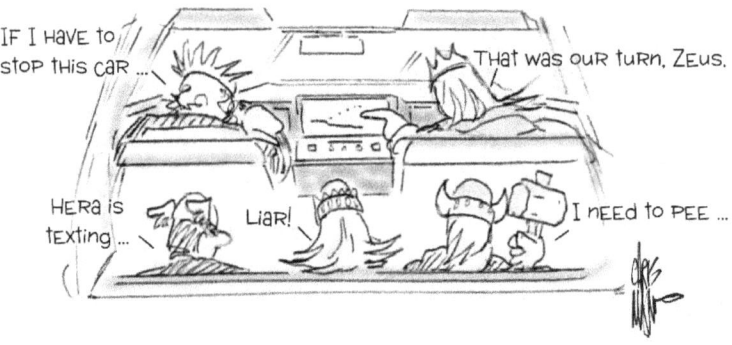

Cartoon REFUGE
Summer 2024

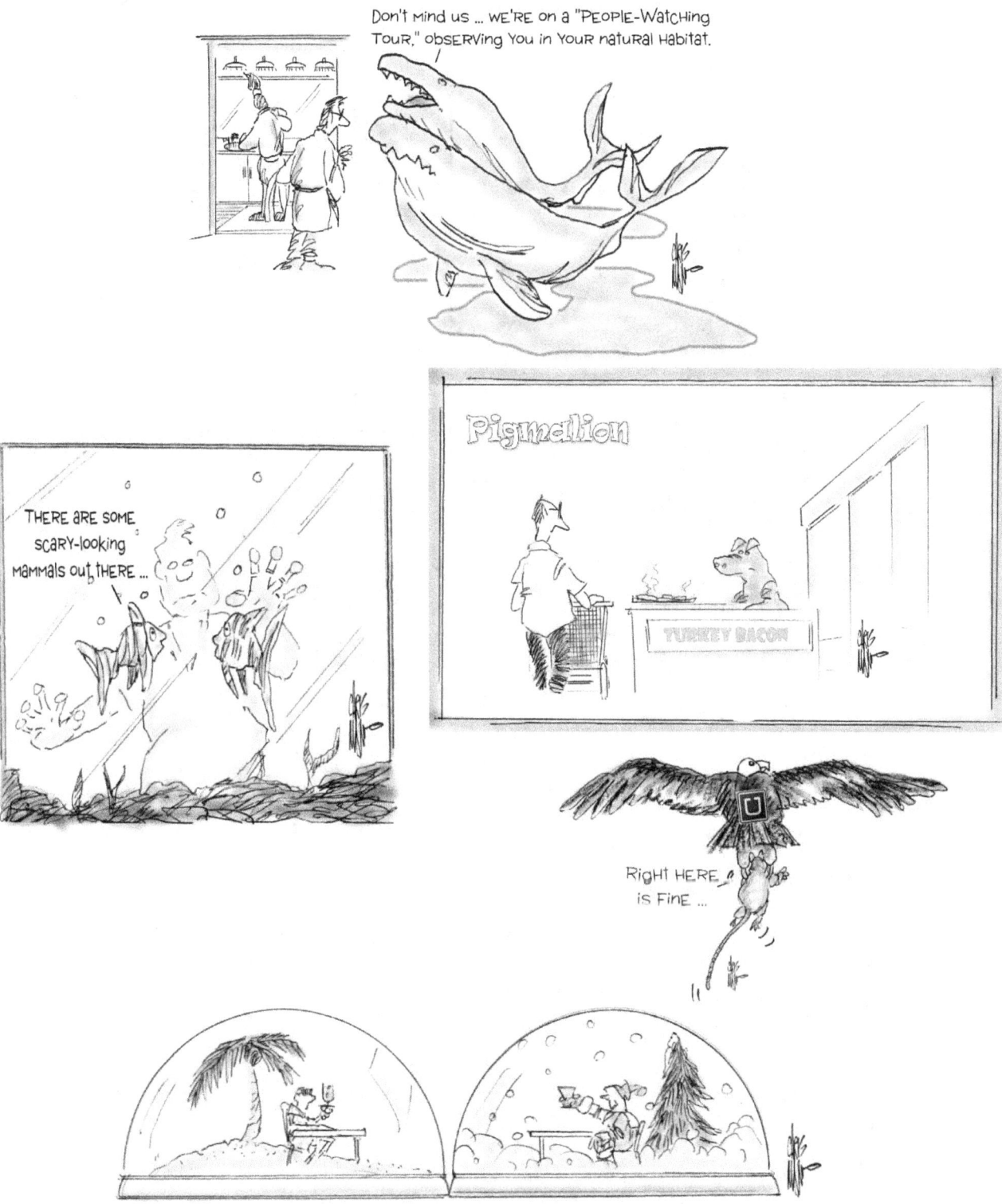

Cartoon REFUGE
Summer 2024

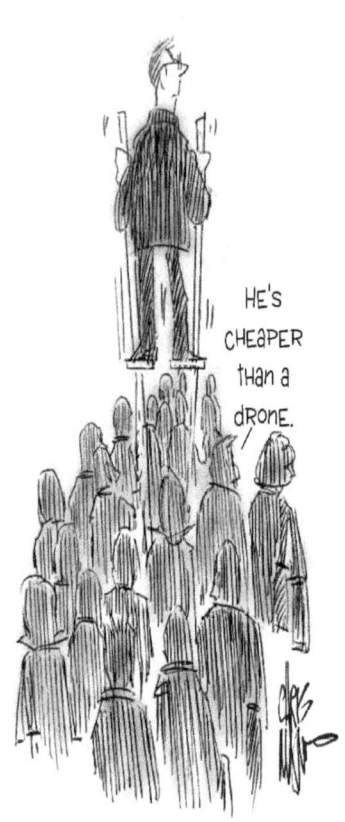

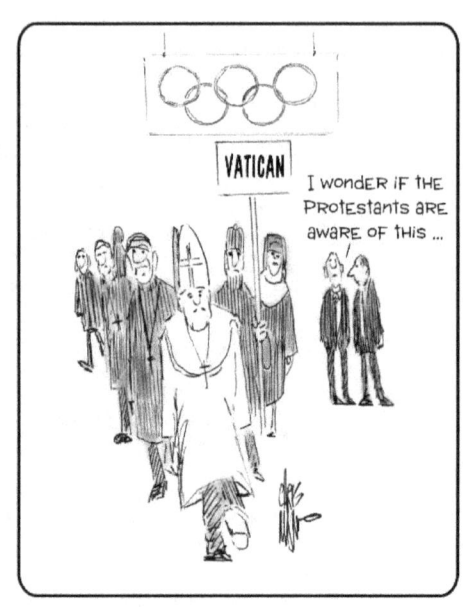

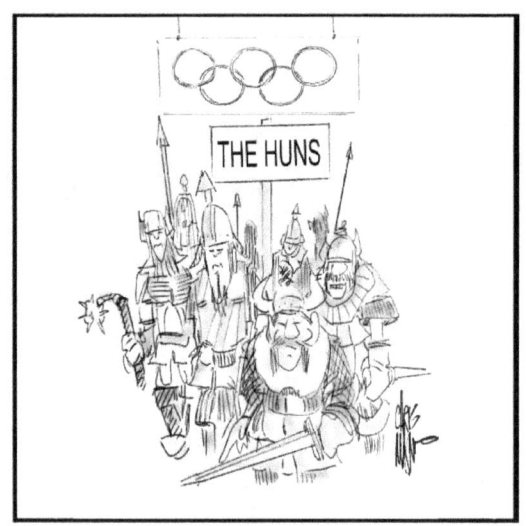

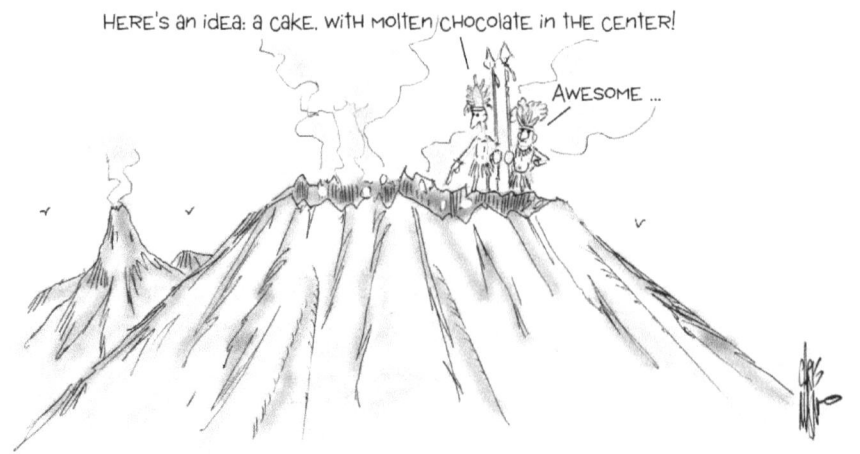

Cartoon REFUGE
Summer 2024

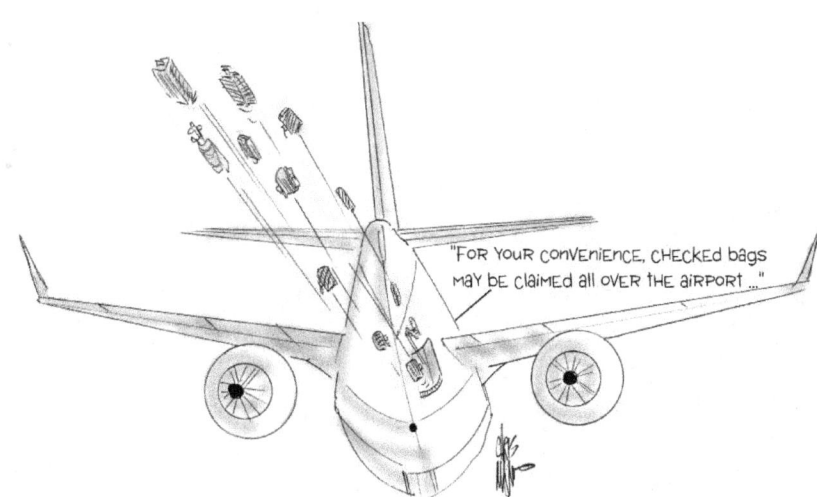

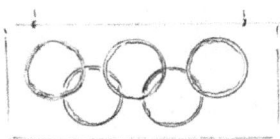

Men's Surfing

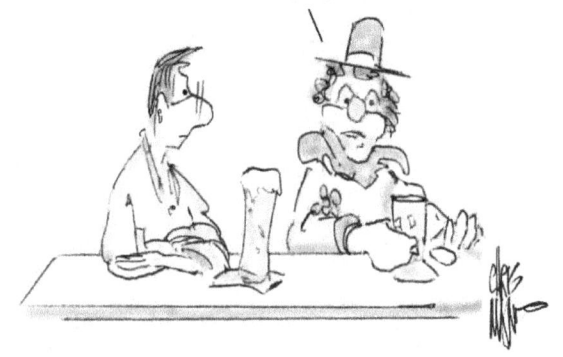

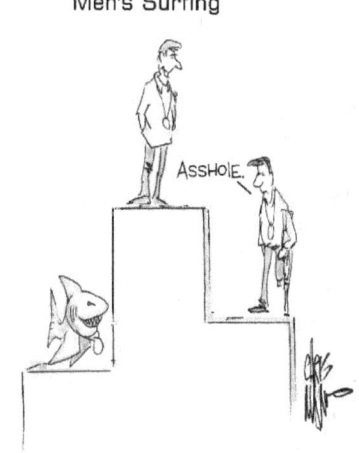

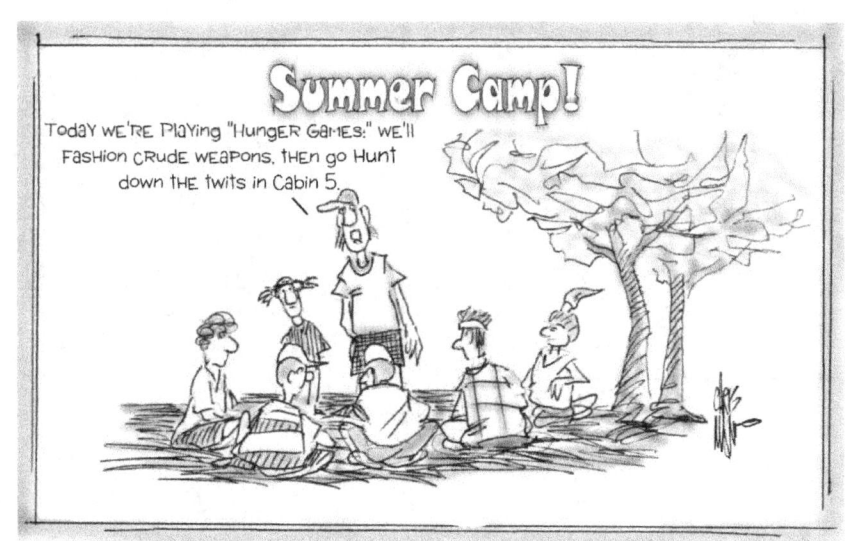

Cartoon REFUGE
Summer 2024

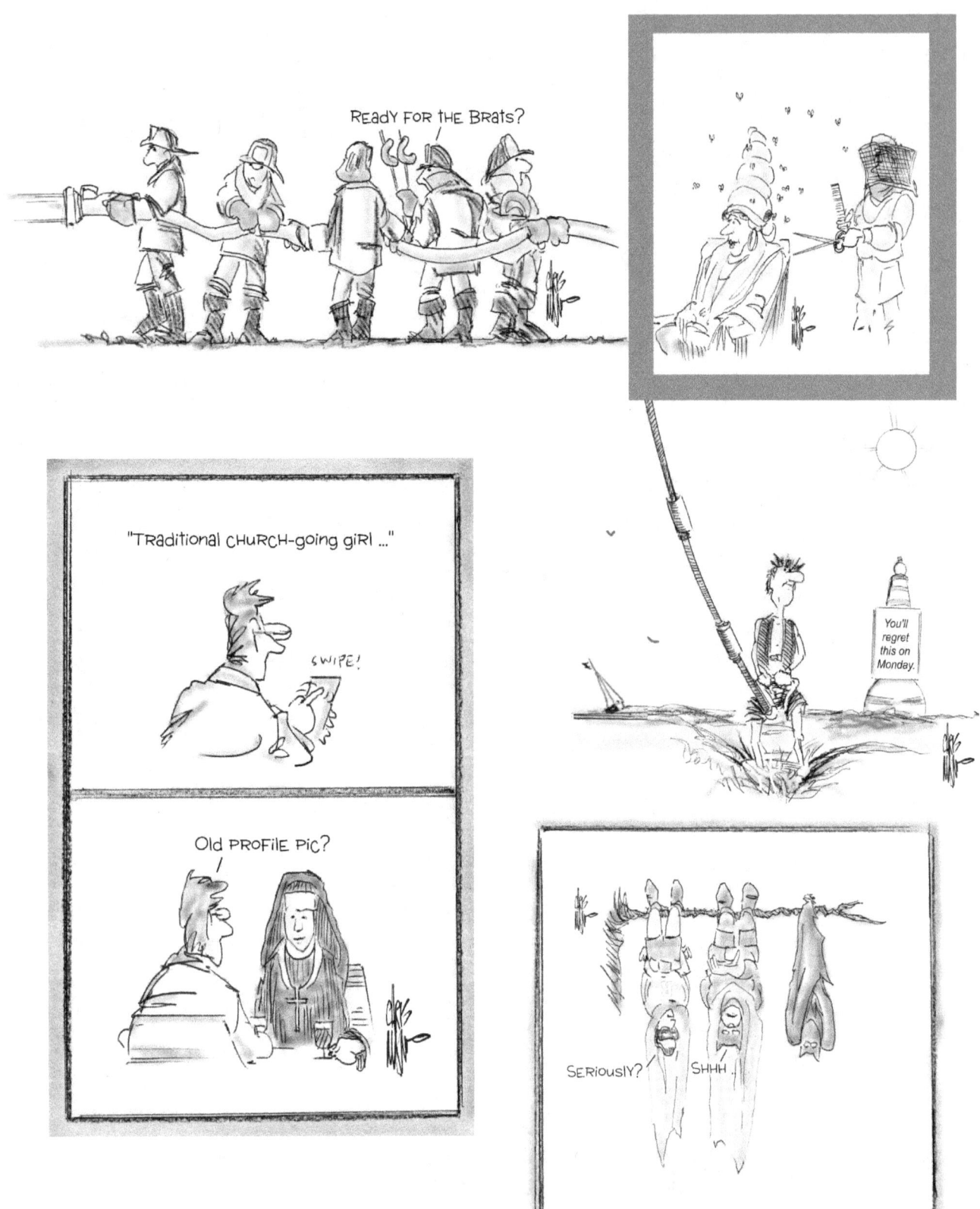

Cartoon REFUGE
Summer 2024

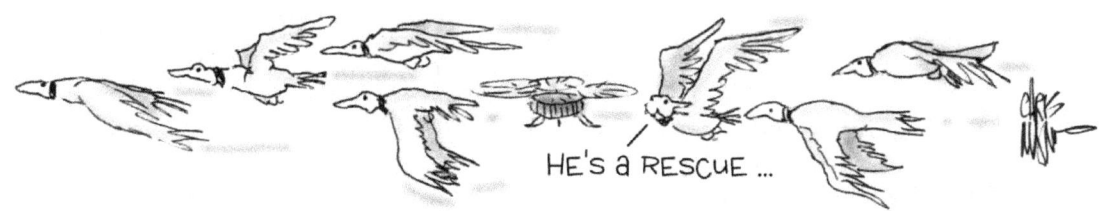

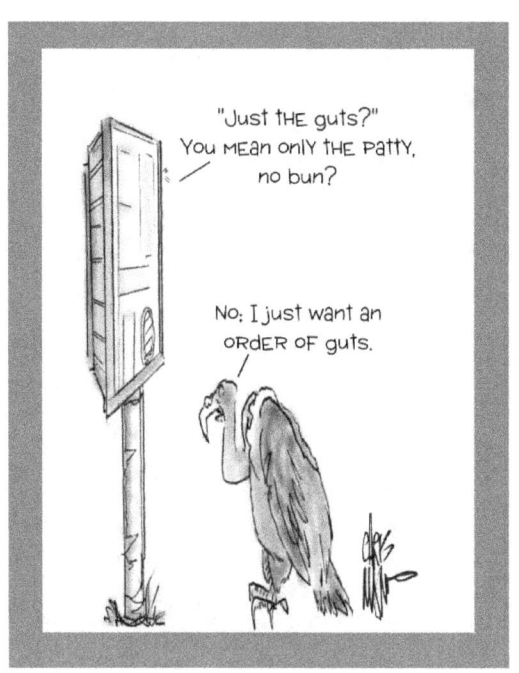

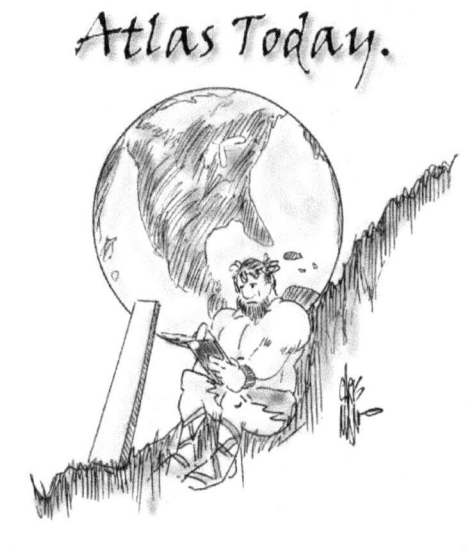

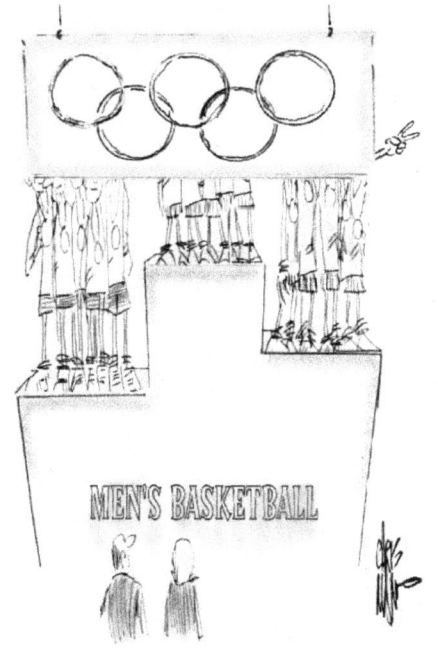

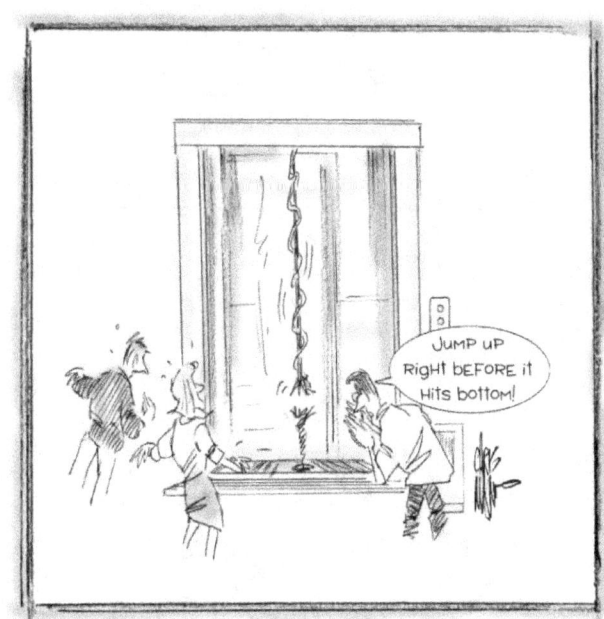

Cartoon REFUGE
Summer 2024

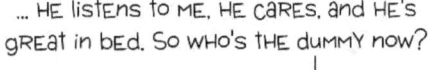
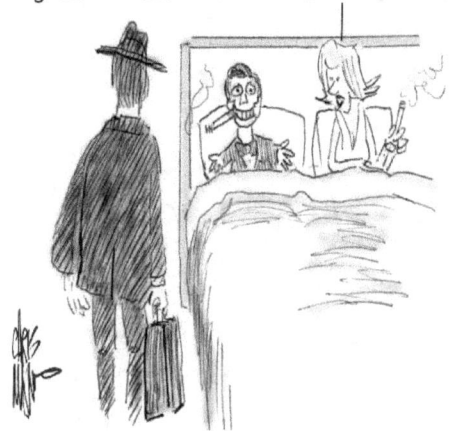
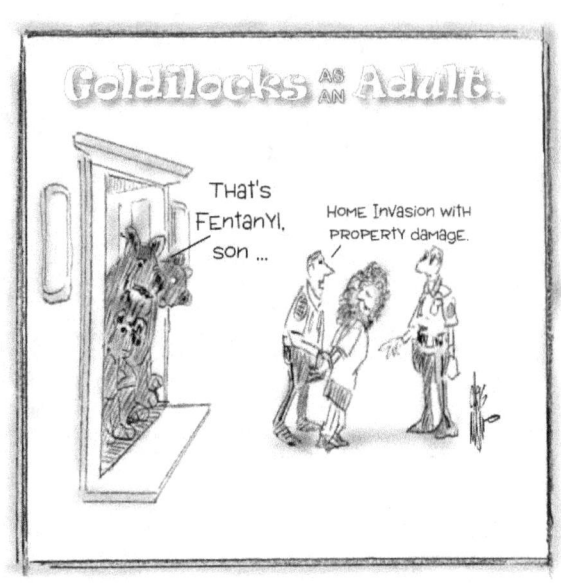
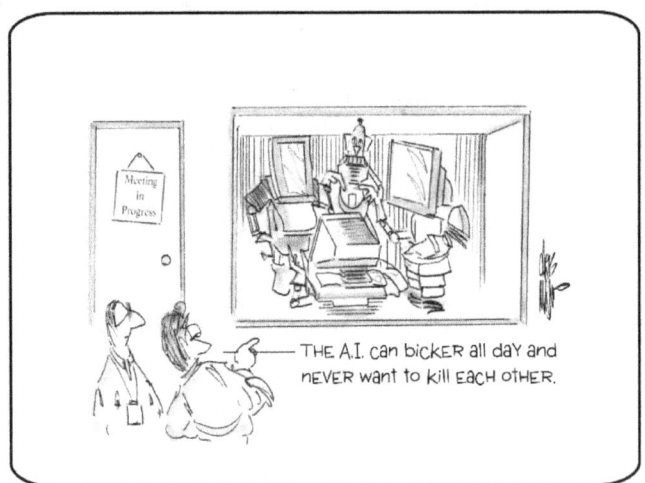
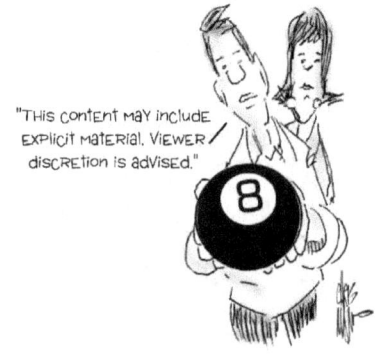

Cartoon REFUGE
Summer 2024

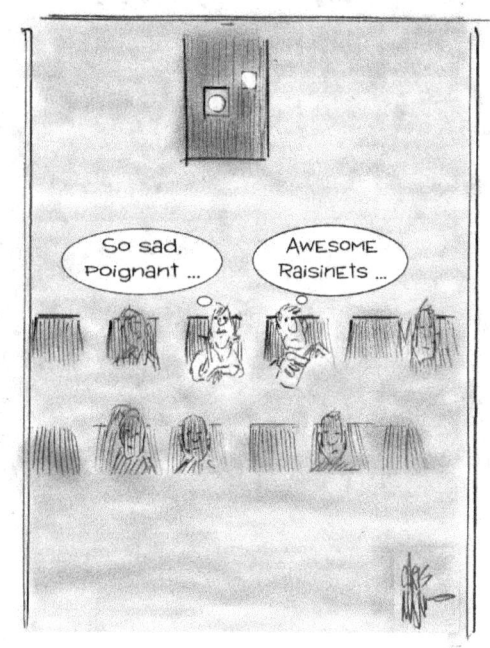
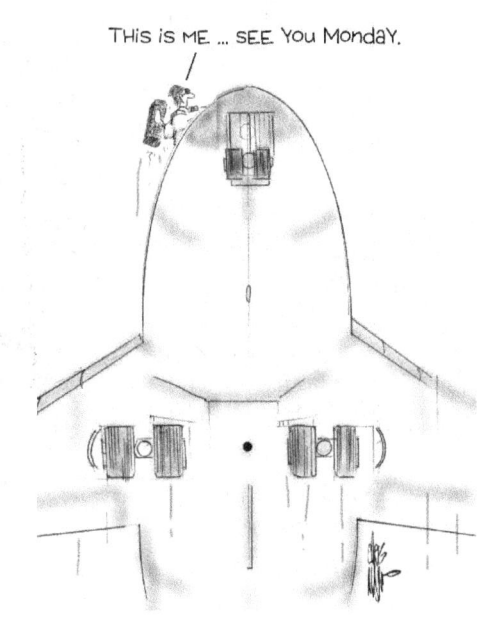
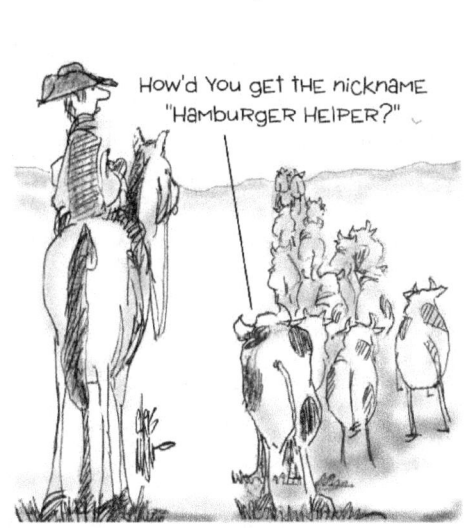
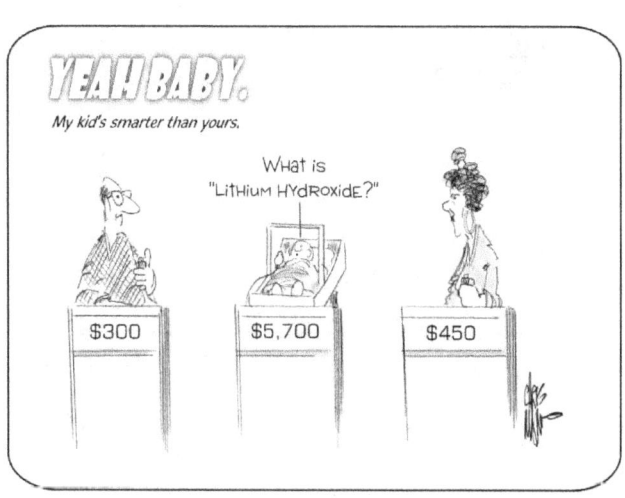
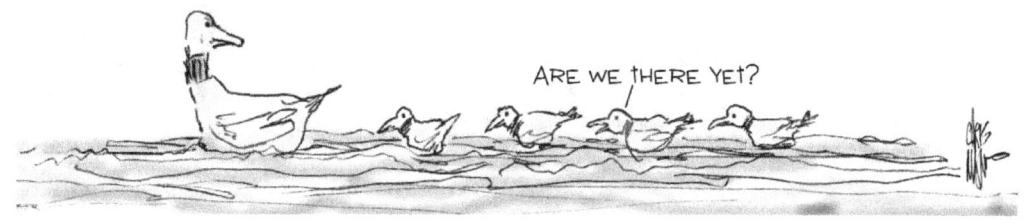

Cartoon REFUGE
Summer 2024

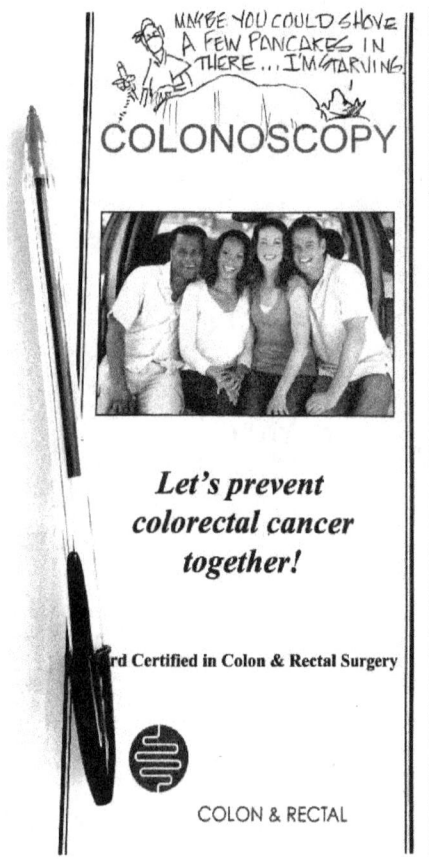
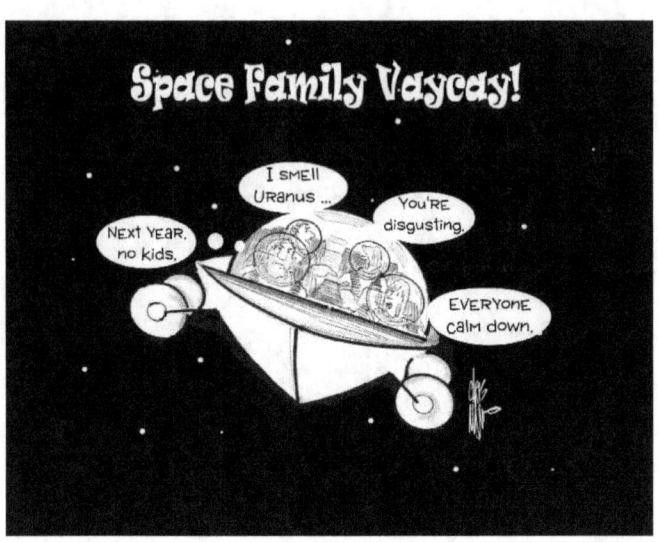
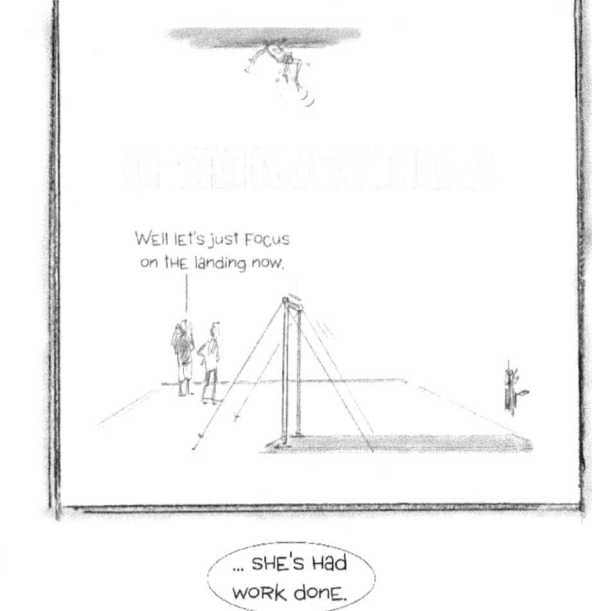
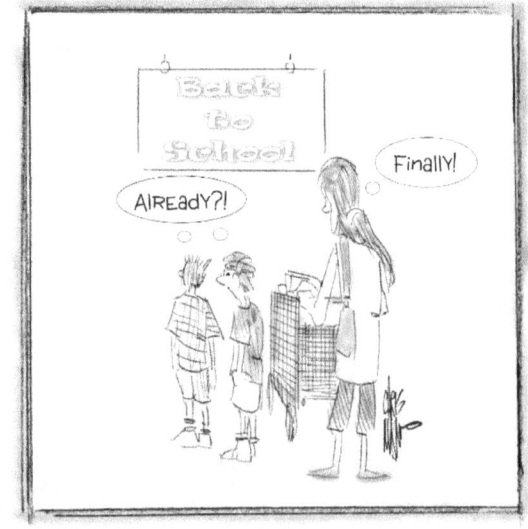
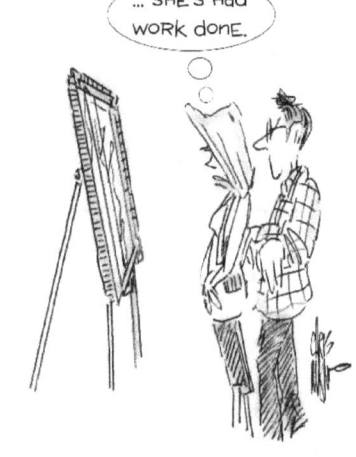

Cartoon REFUGE
Summer 2024

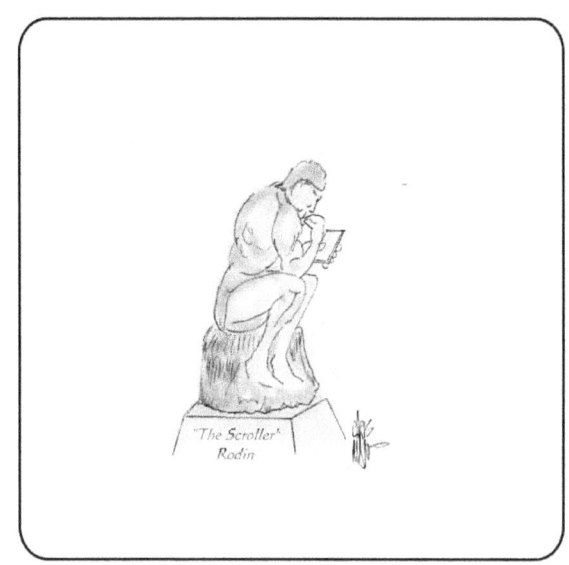

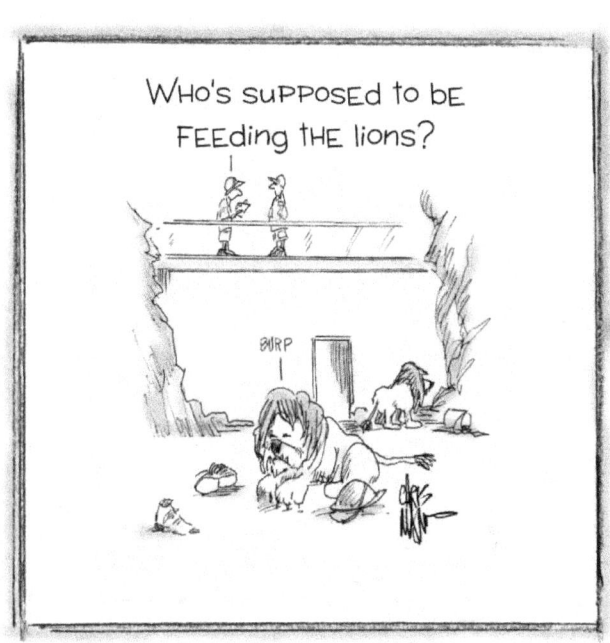

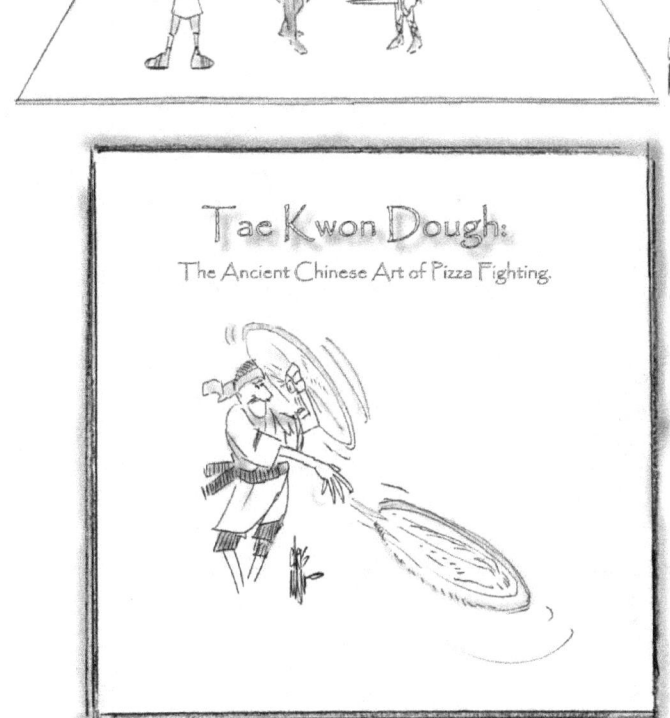

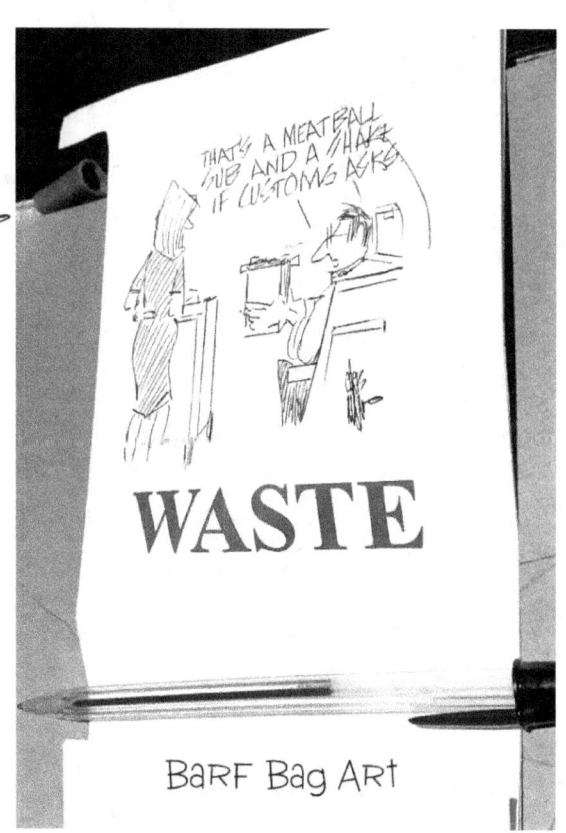

Cartoon REFUGE
Summer 2024

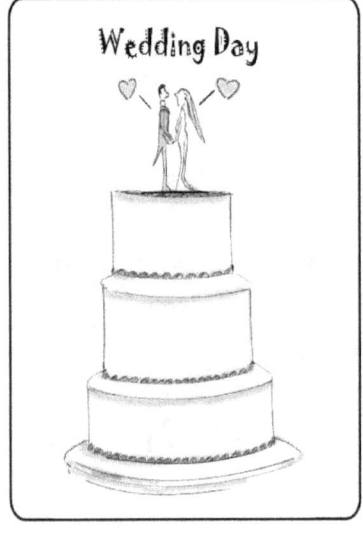
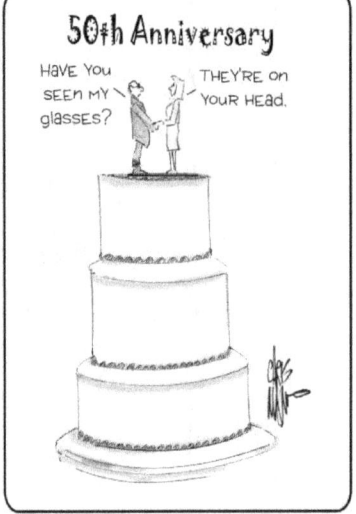
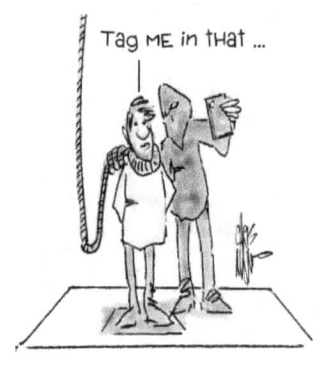
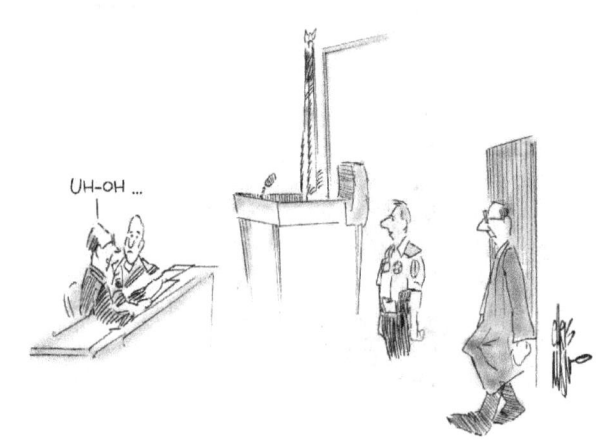
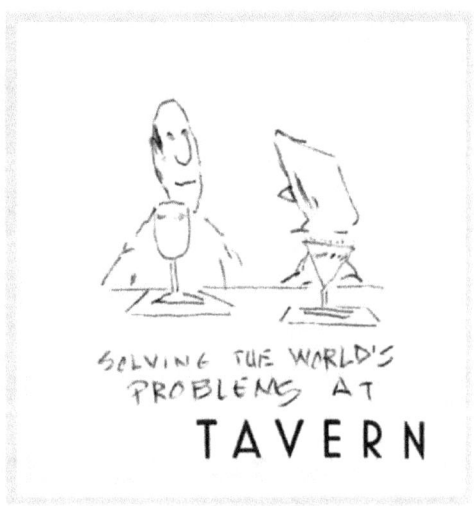
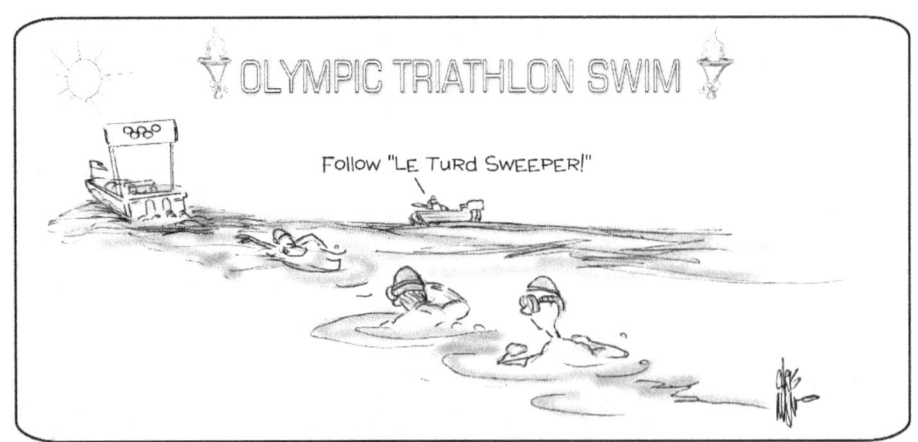

Cartoon REFUGE
Summer 2024

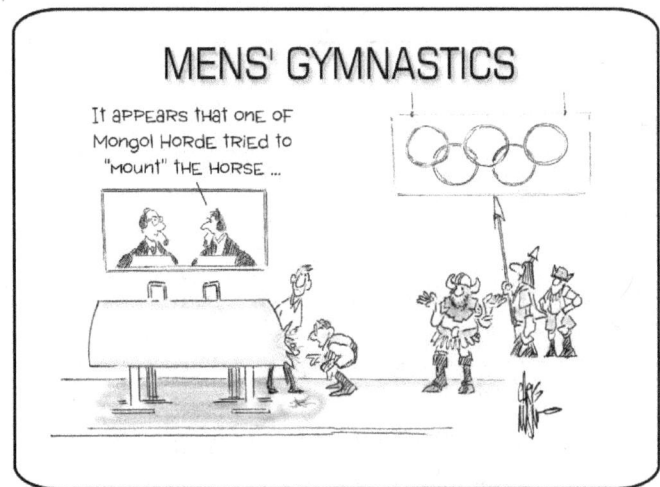
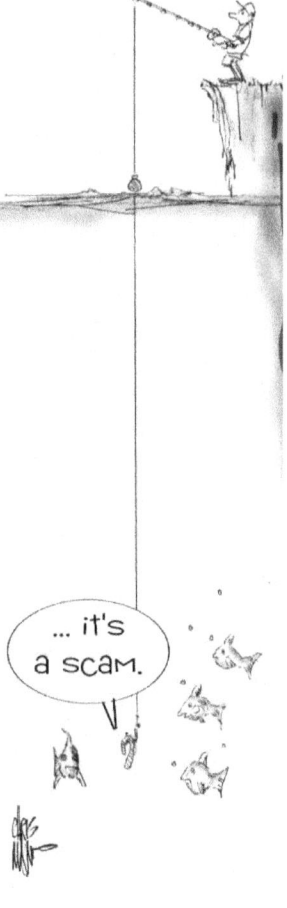
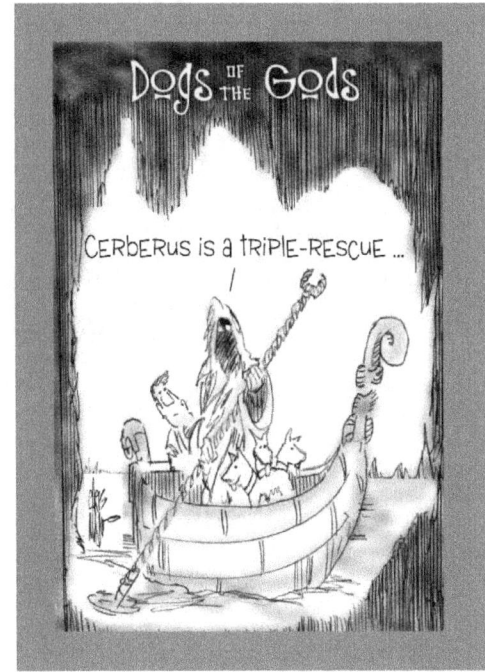
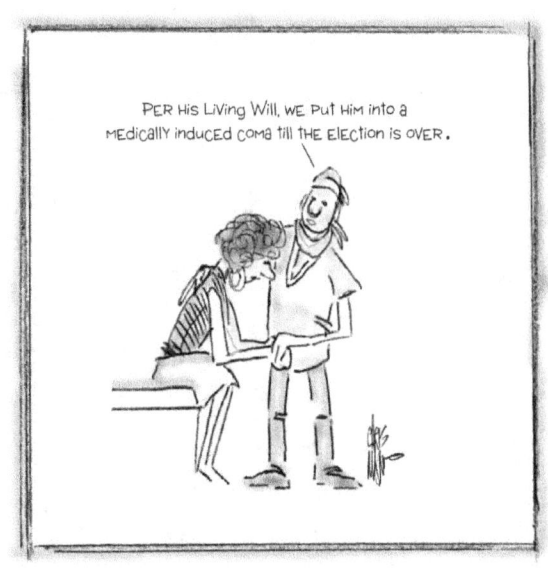
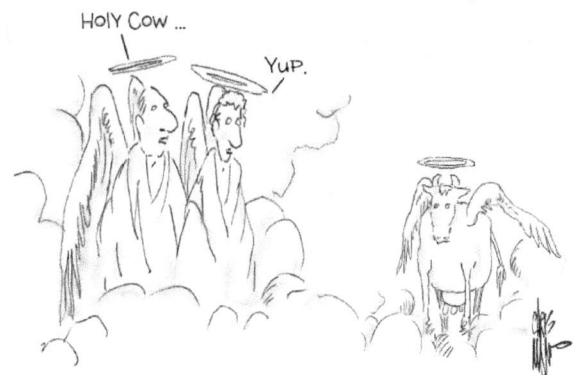

Cartoon REFUGE
Summer 2024

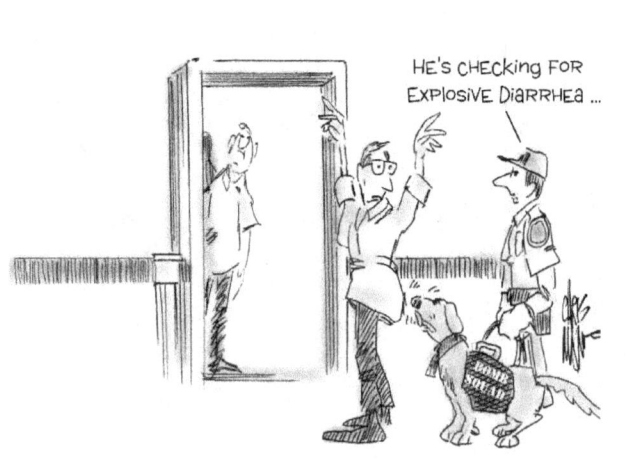

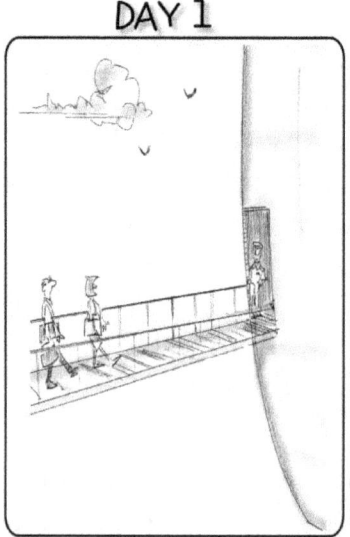

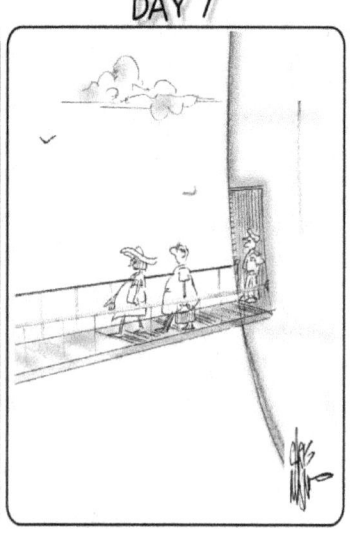

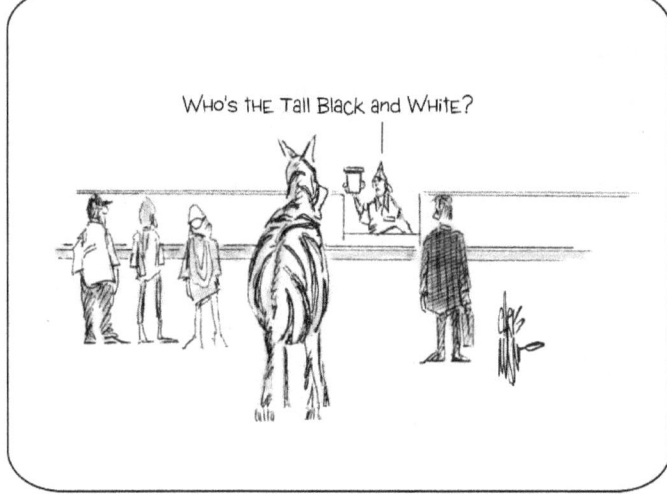

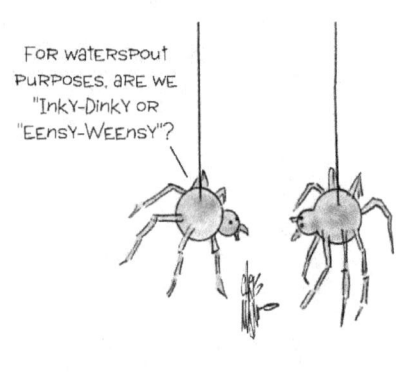

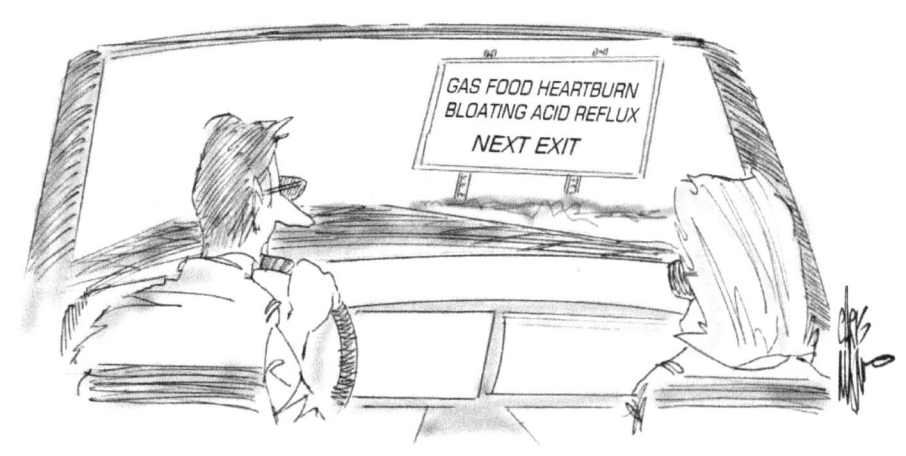

Cartoon REFUGE
Summer 2024

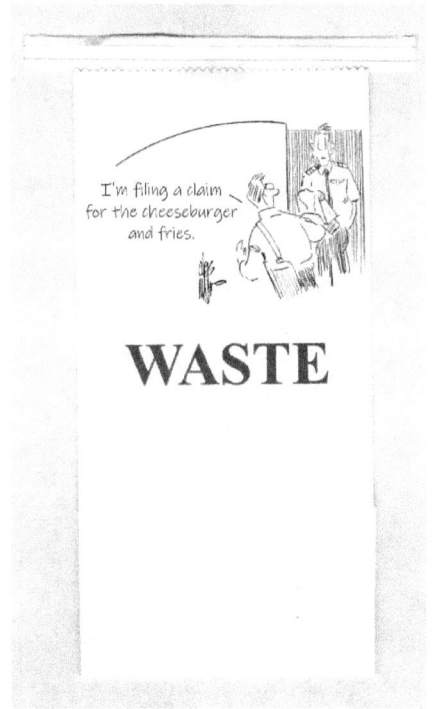

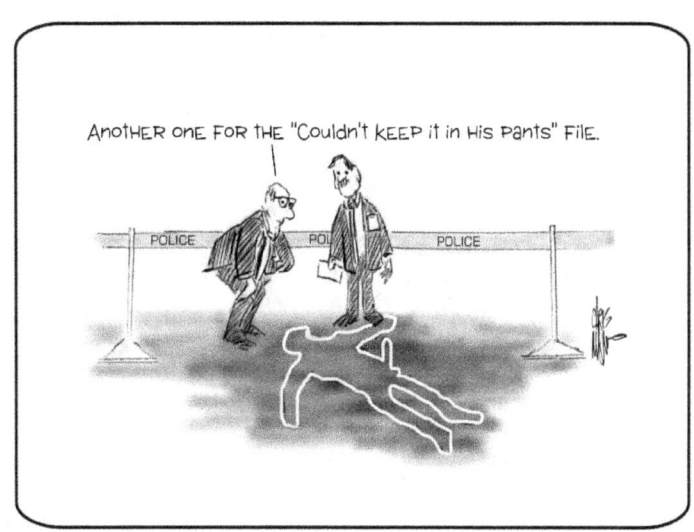

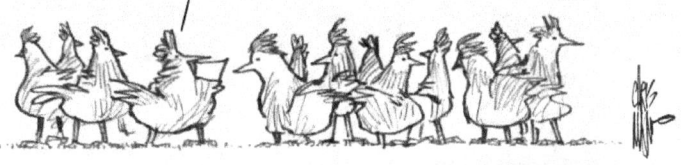

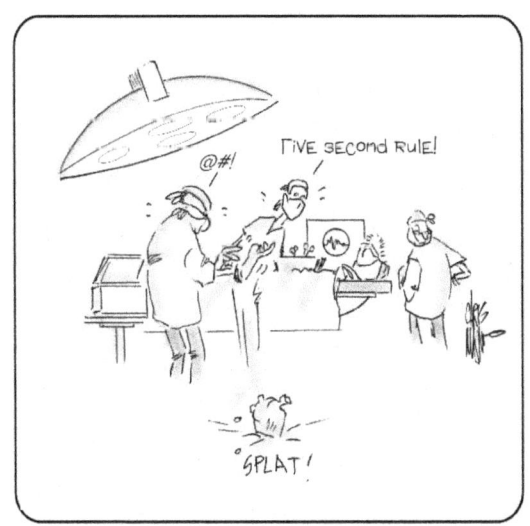

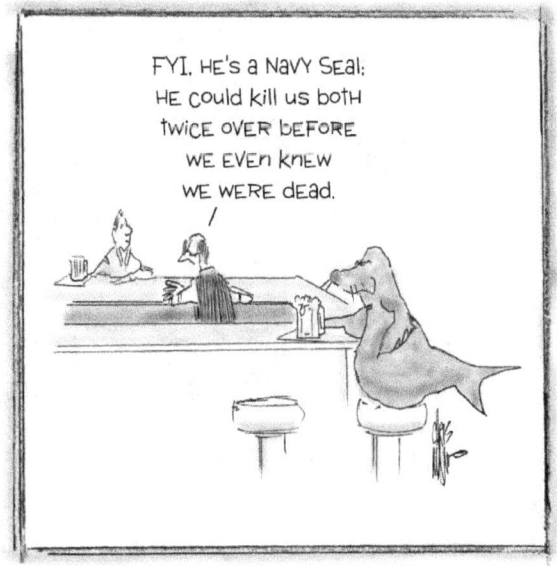

Cartoon REFUGE
Summer 2024

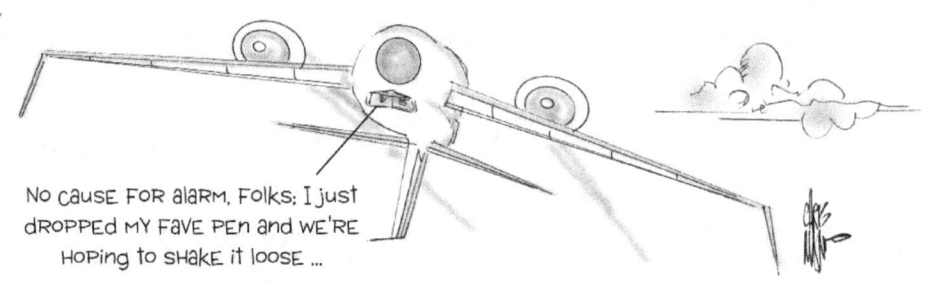

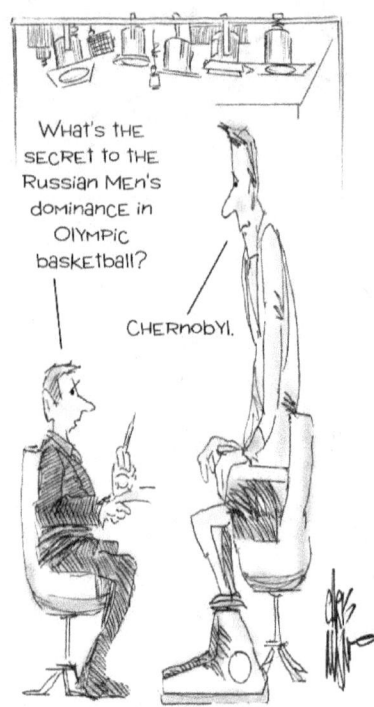

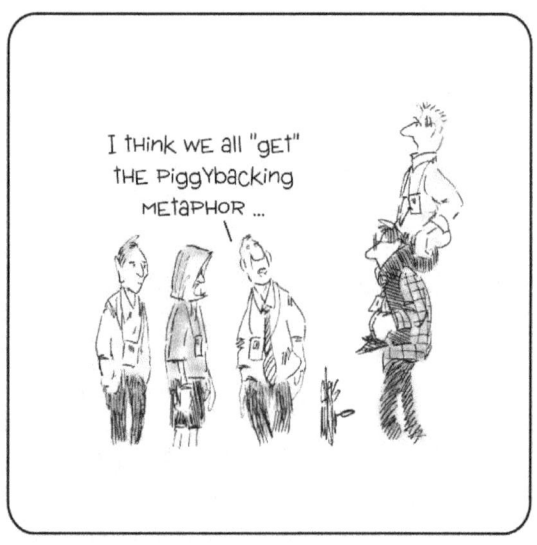

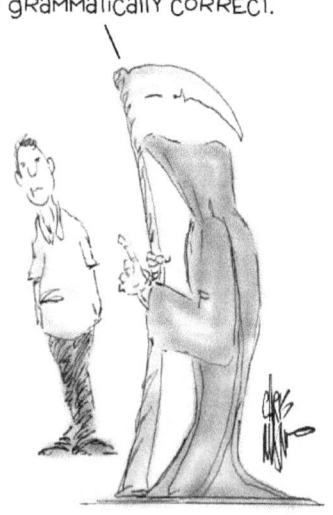

Cartoon REFUGE
Summer 2024

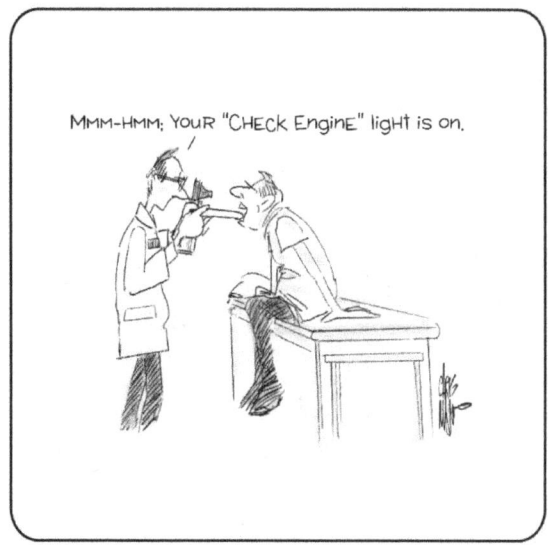

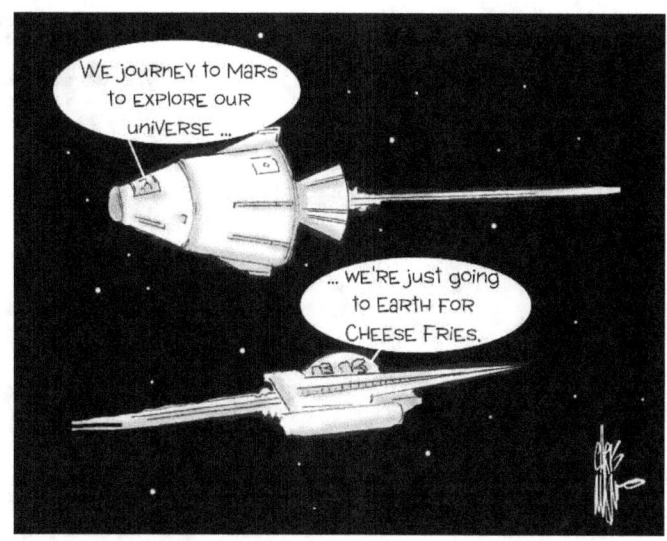

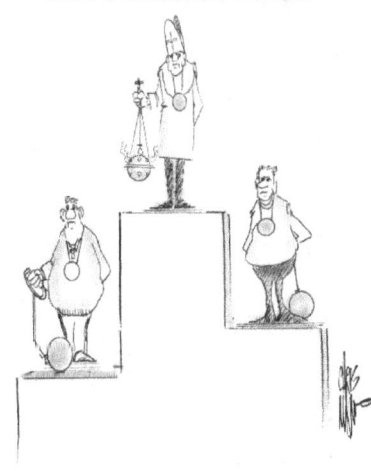

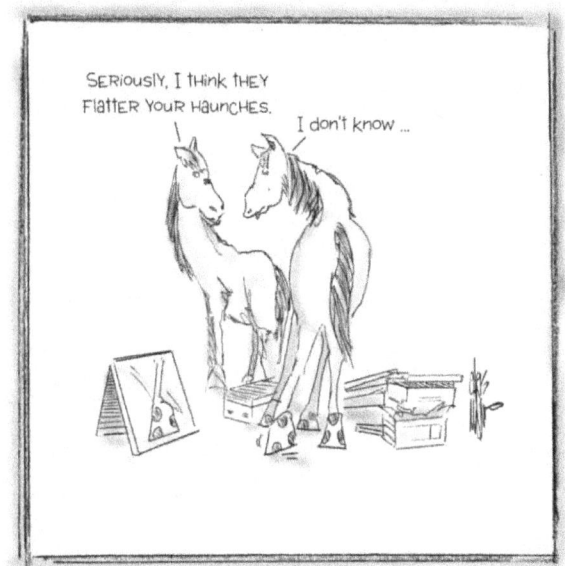

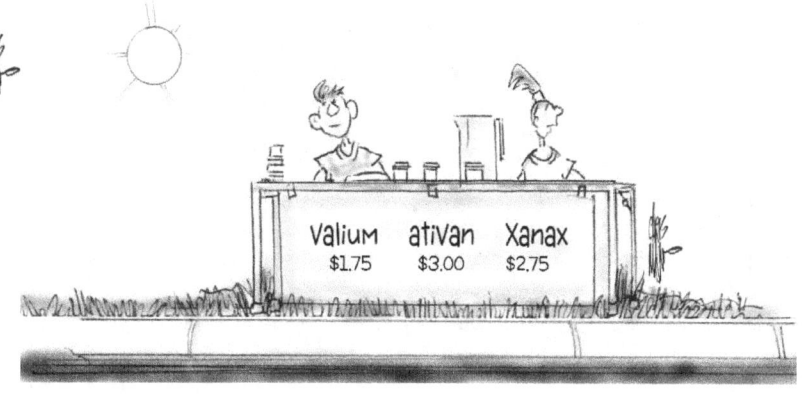

Cartoon REFUGE
Summer 2024

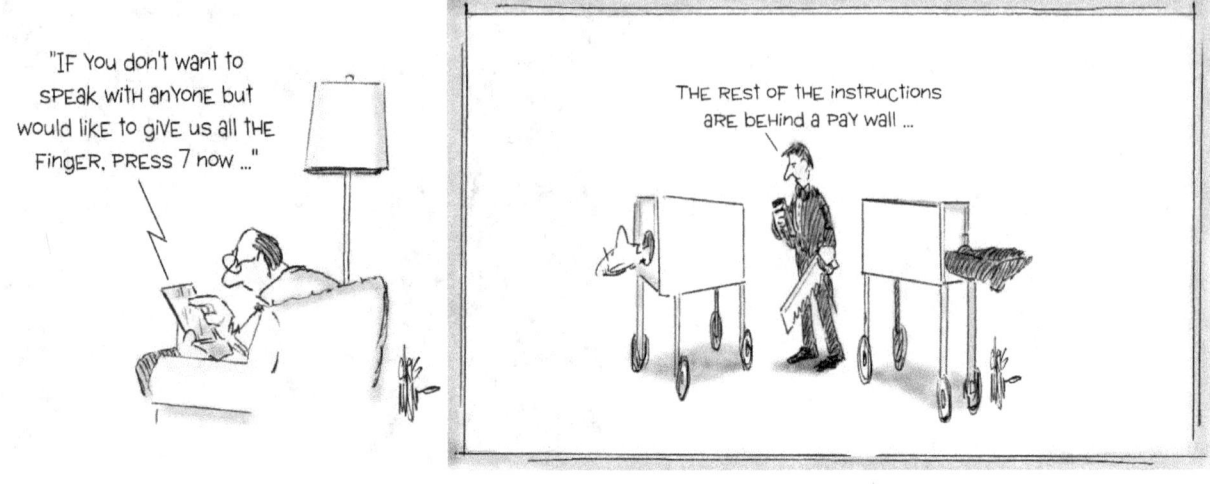

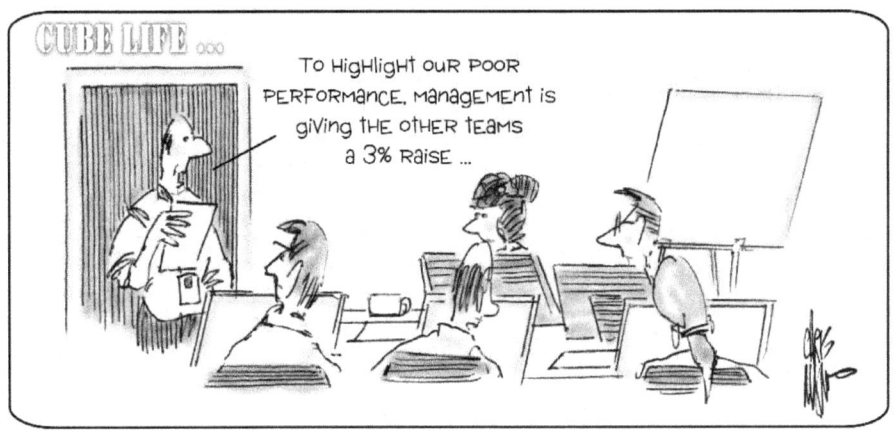

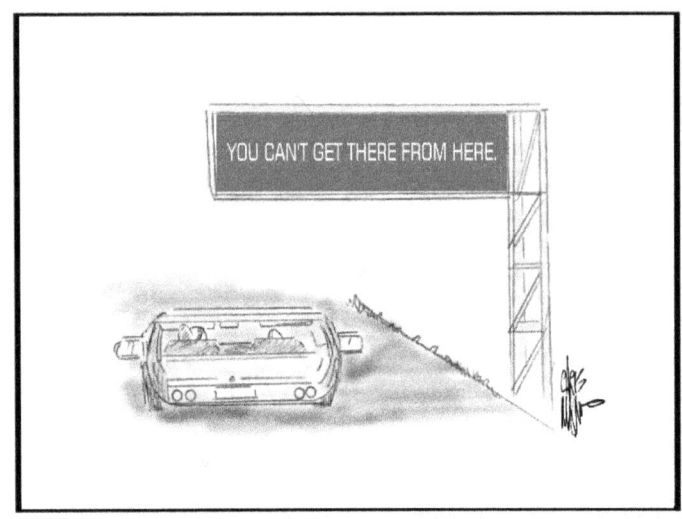

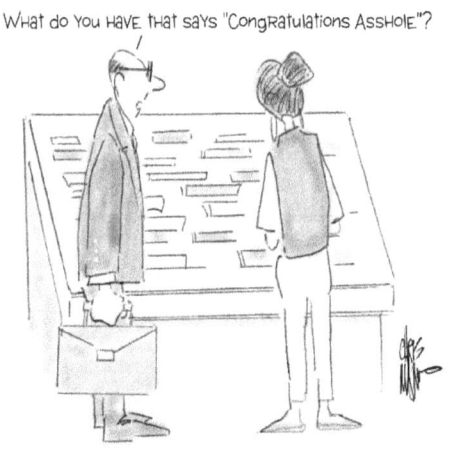

Cartoon REFUGE
Summer 2024

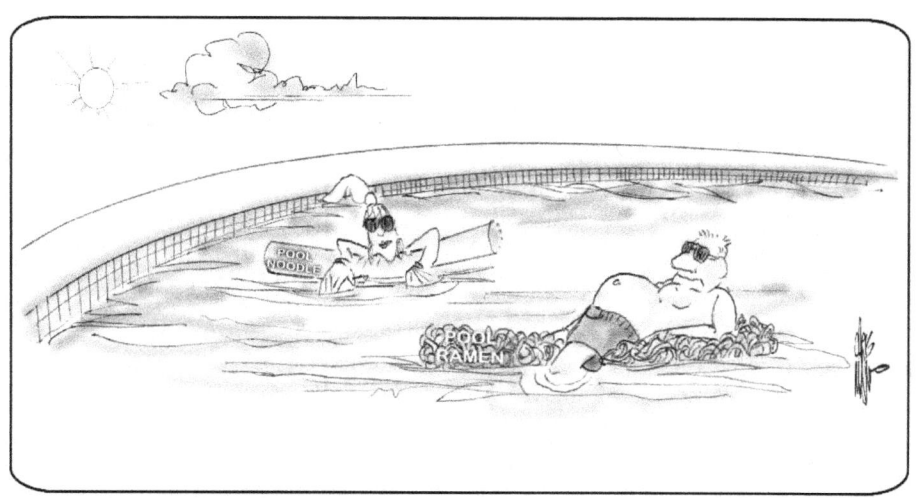

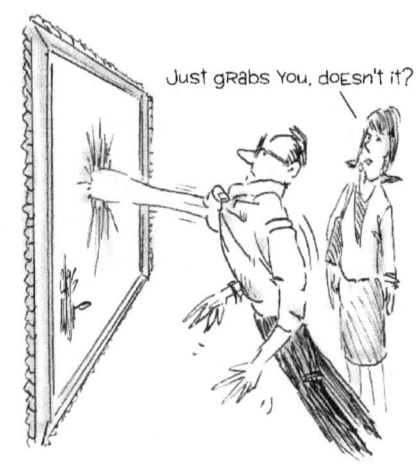

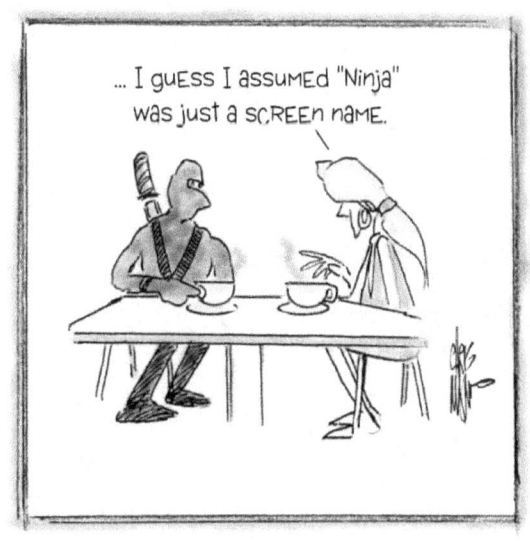

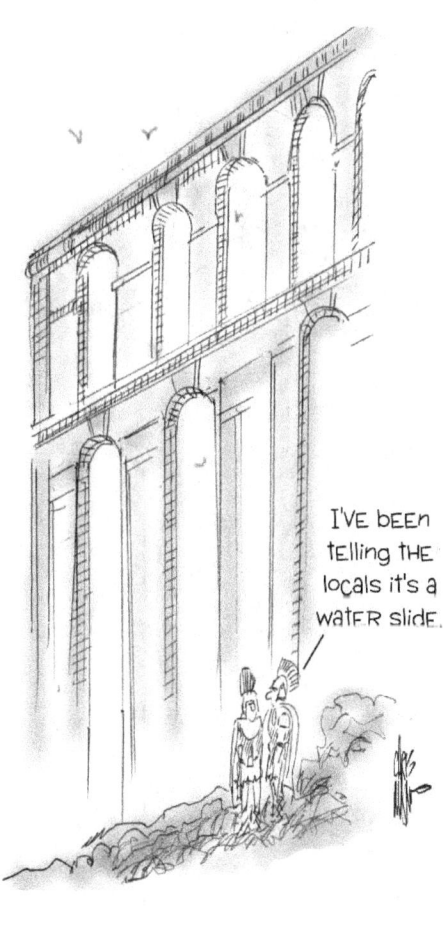

Cartoon REFUGE
Summer 2024

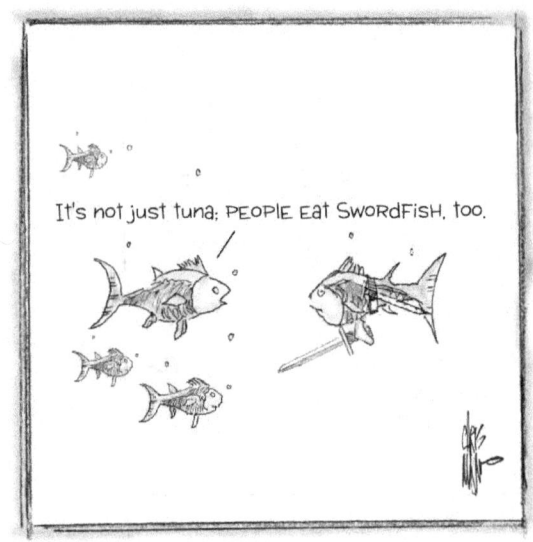
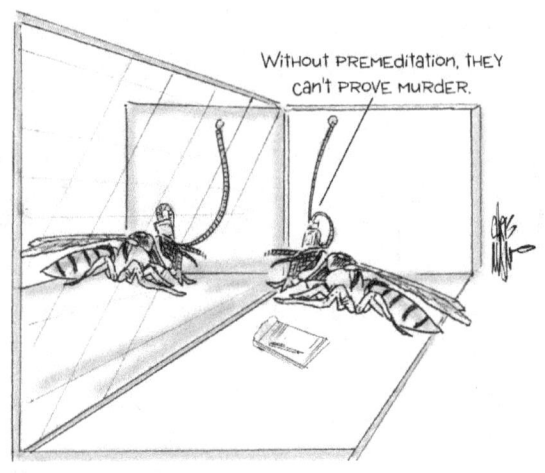
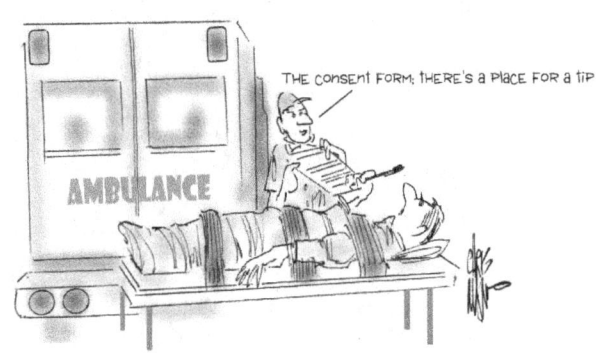
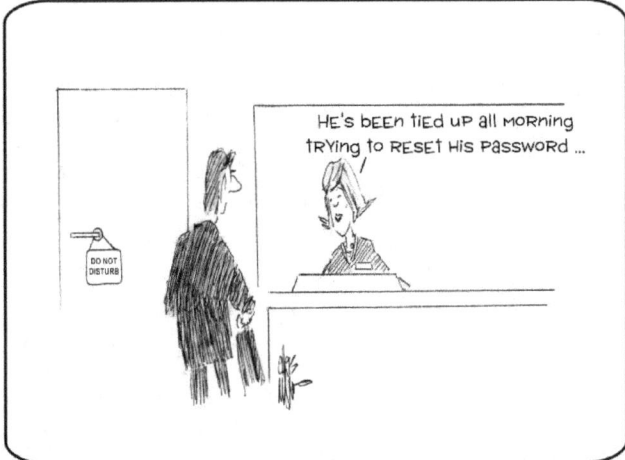
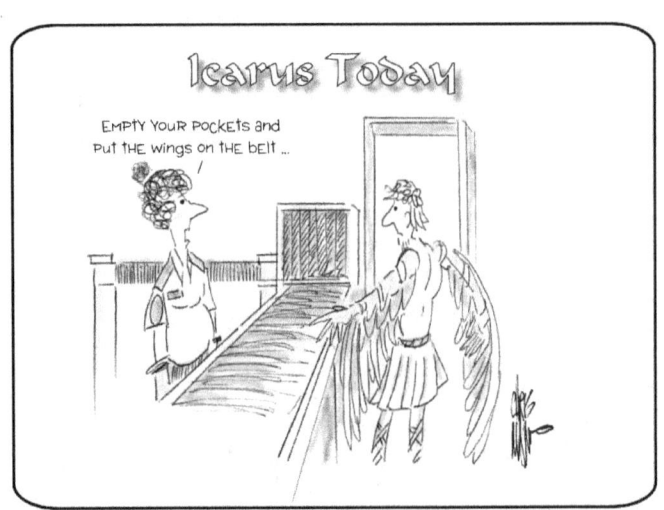

Cartoon REFUGE
Summer 2024

Michelangelo

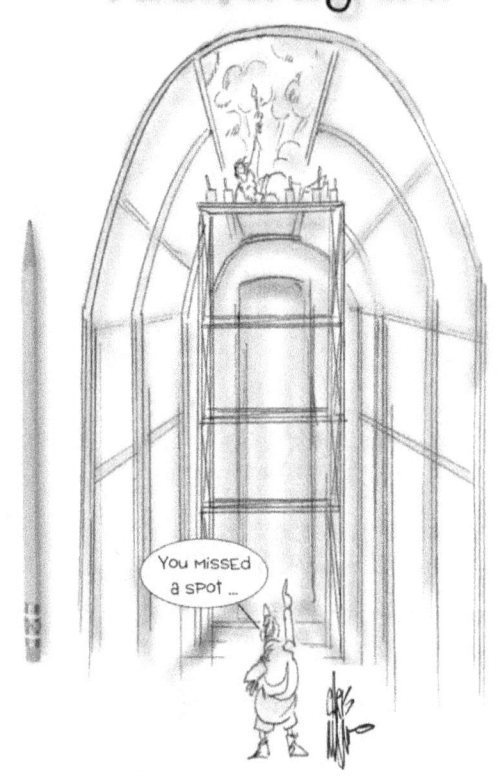

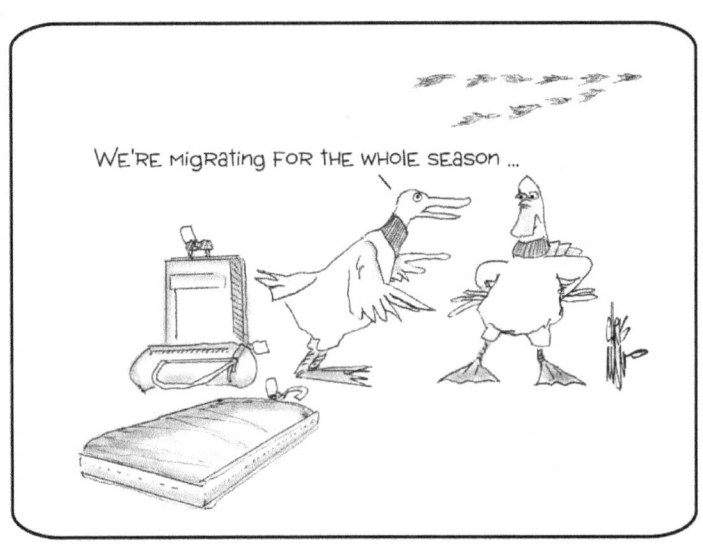

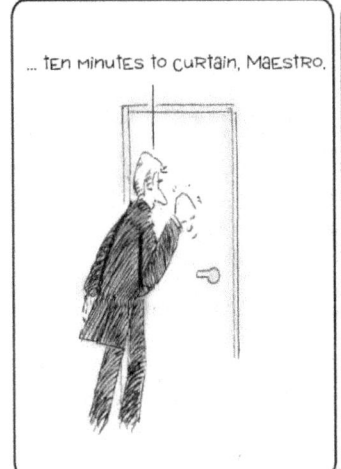

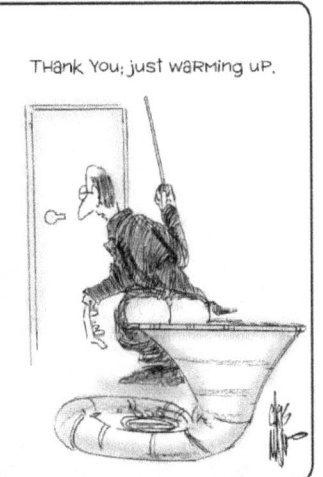

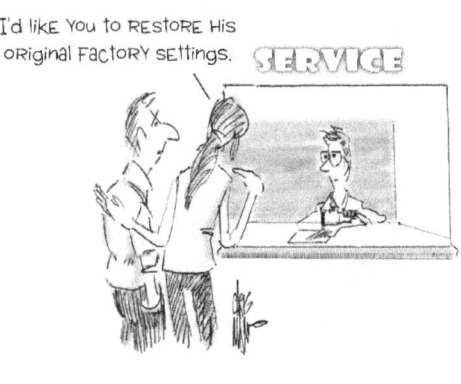

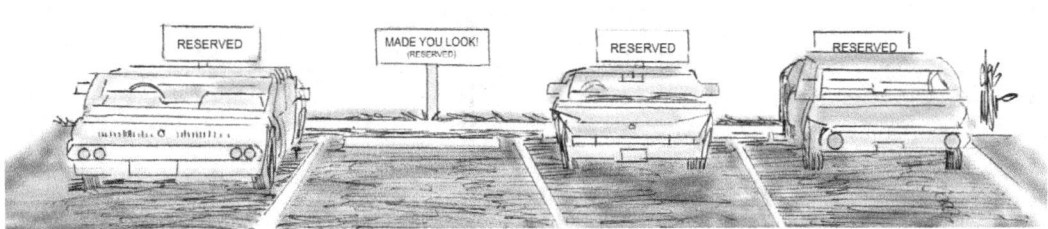

Cartoon REFUGE
Summer 2024

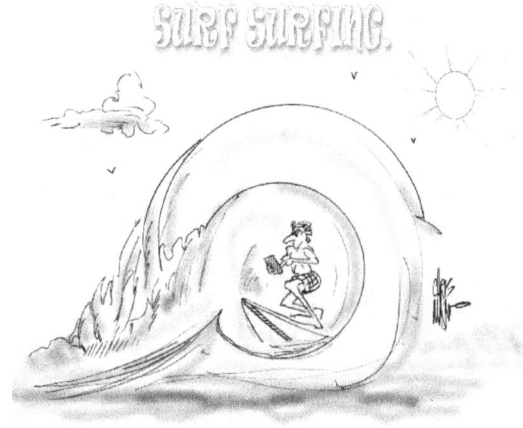

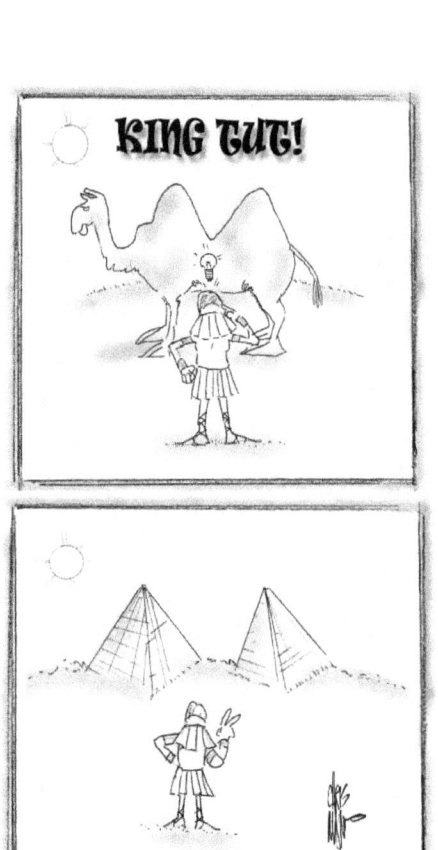

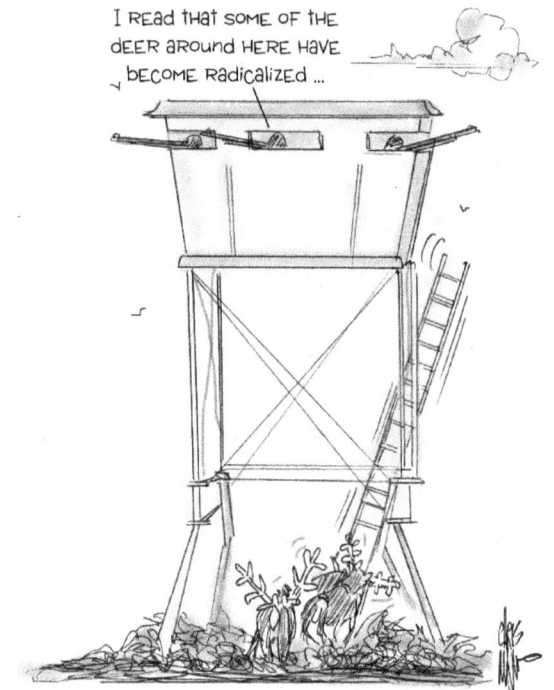

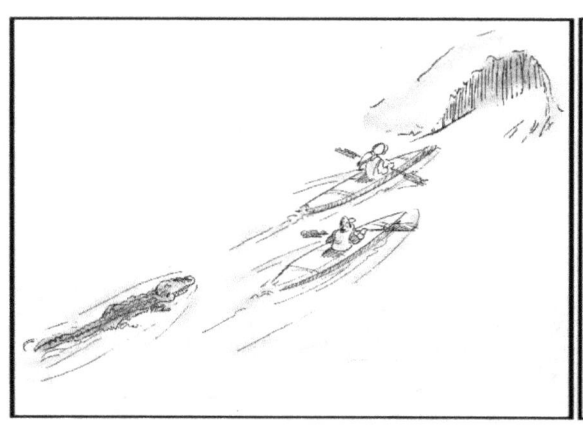

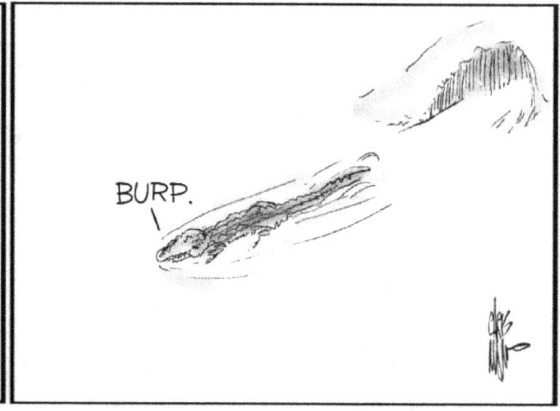

Cartoon REFUGE
Summer 2024

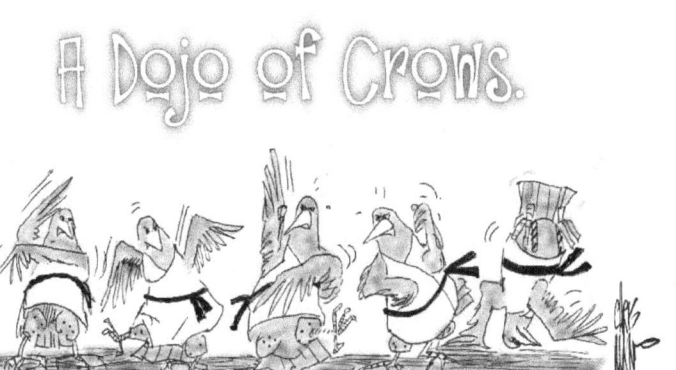

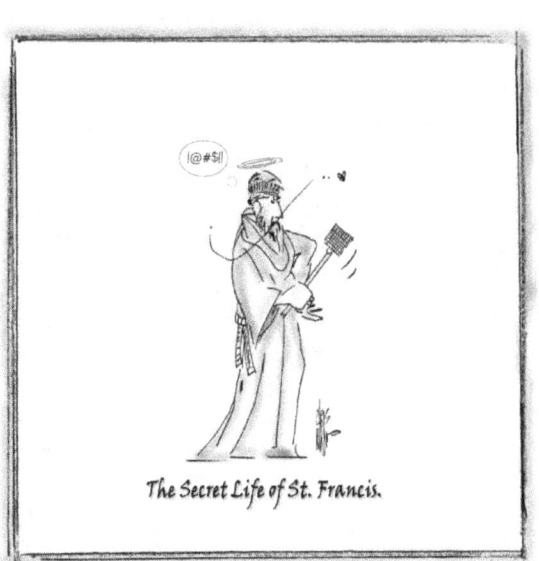

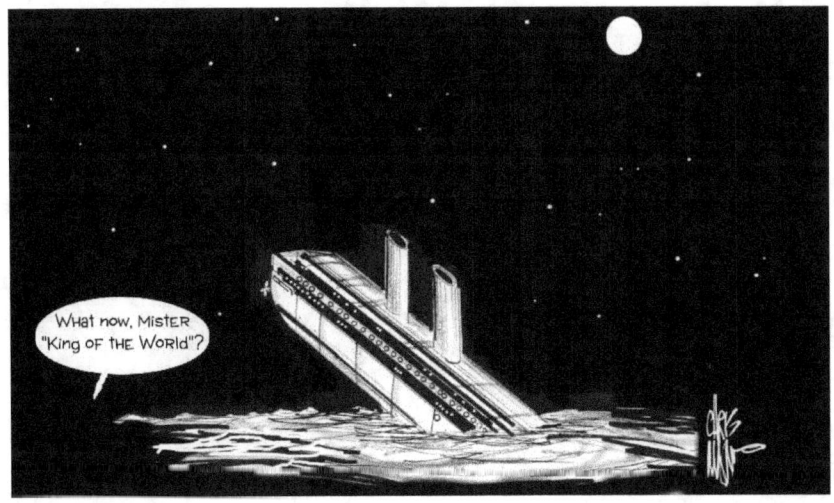

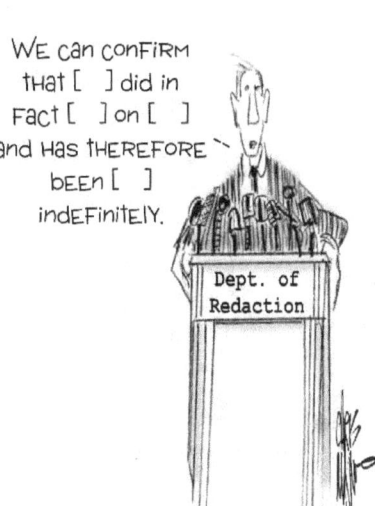

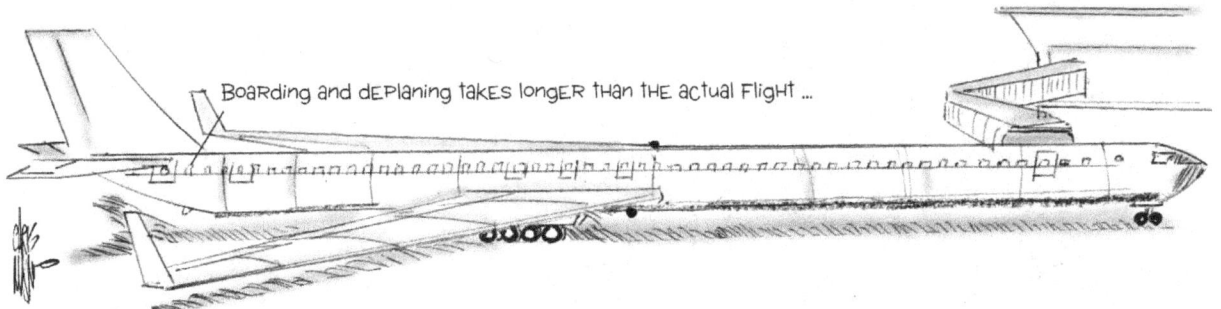

Cartoon REFUGE
Summer 2024

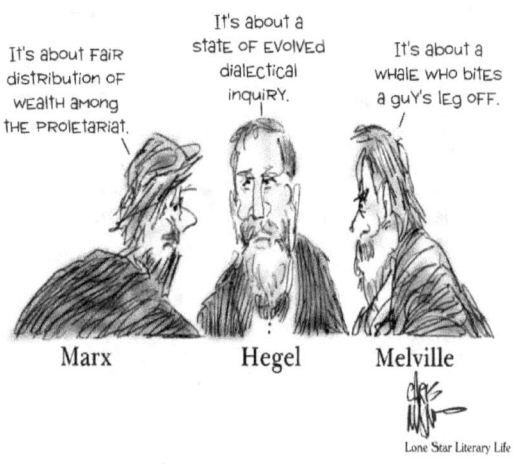

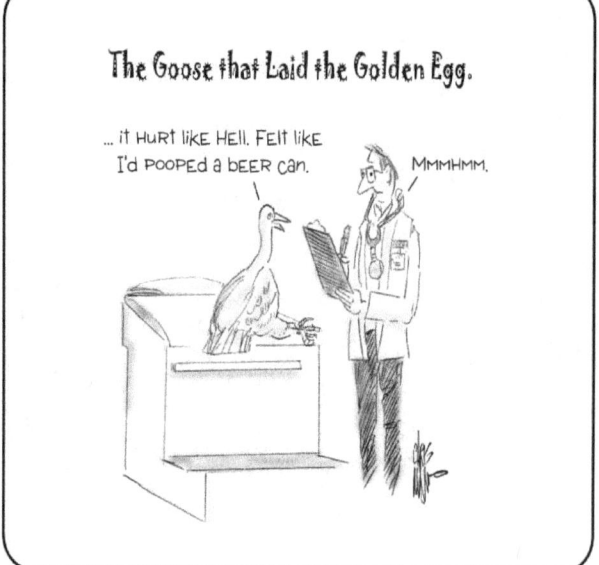

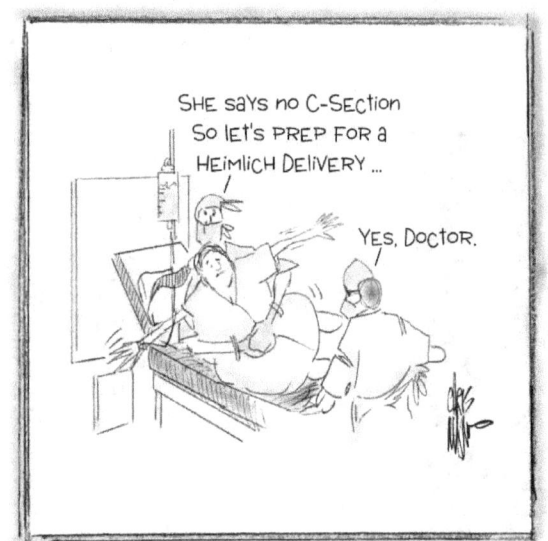

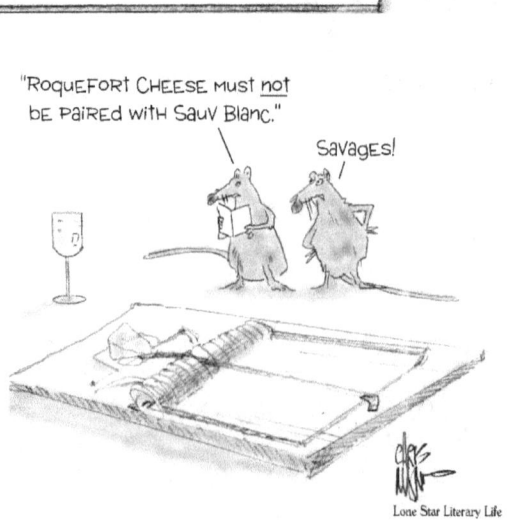

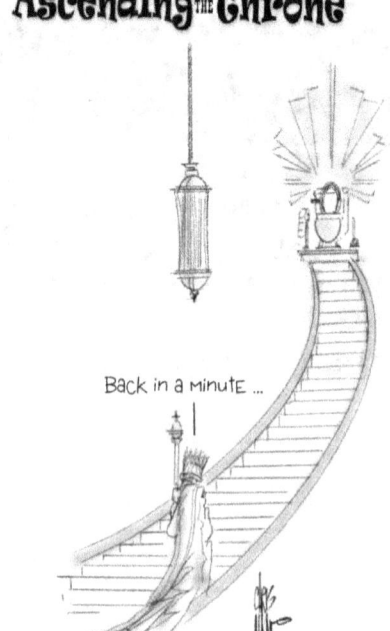

Cartoon REFUGE
Summer 2024

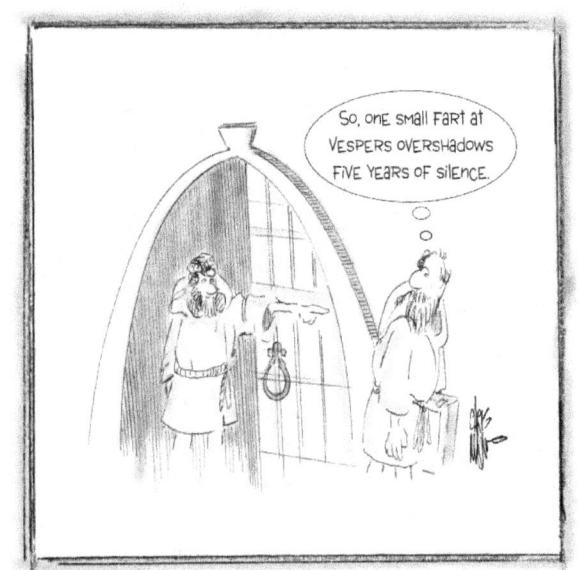
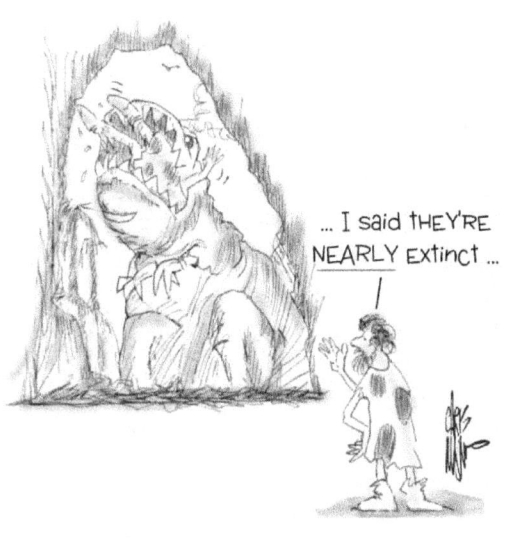
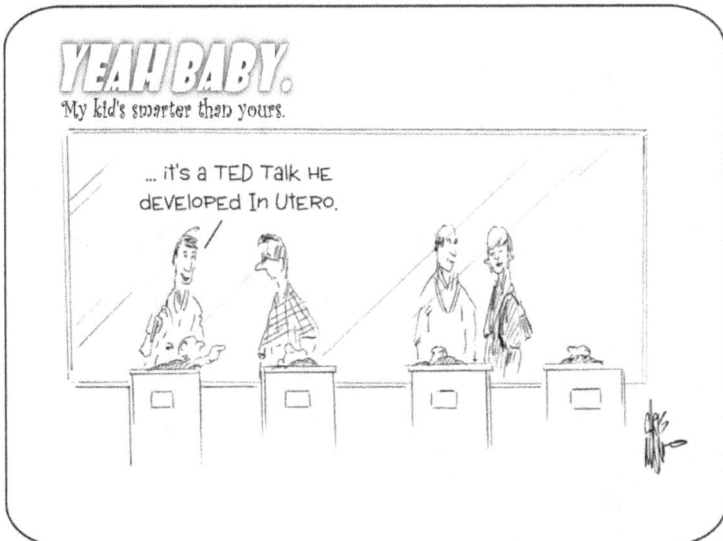
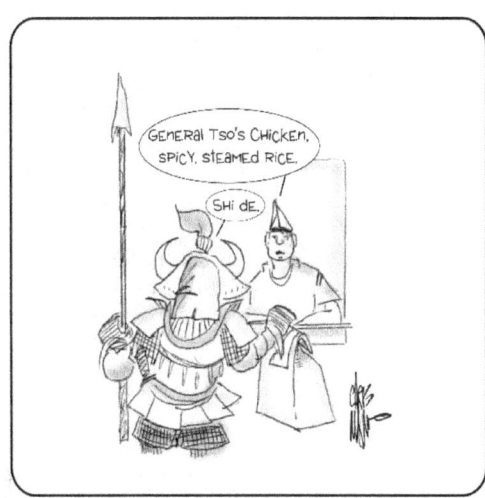
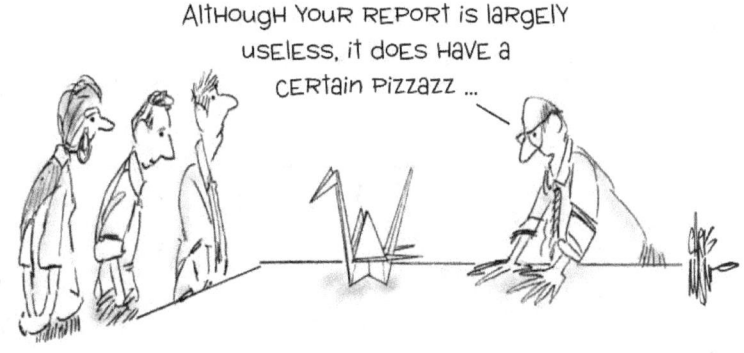

Cartoon REFUGE
Summer 2024

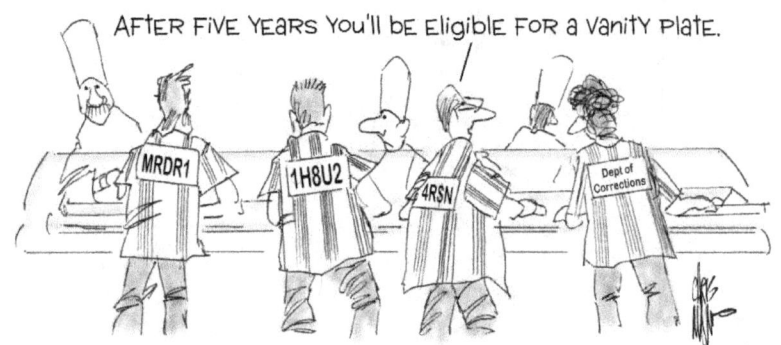
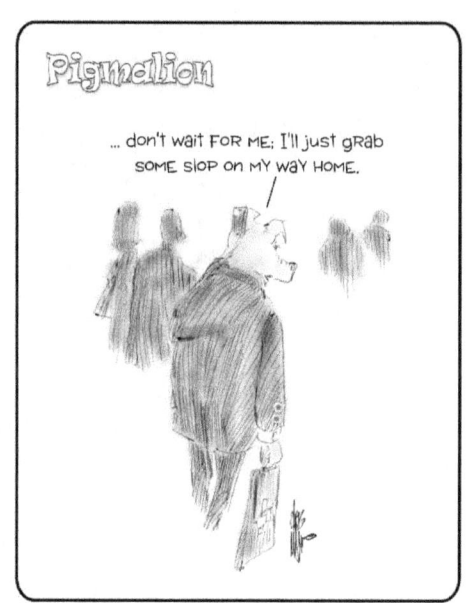
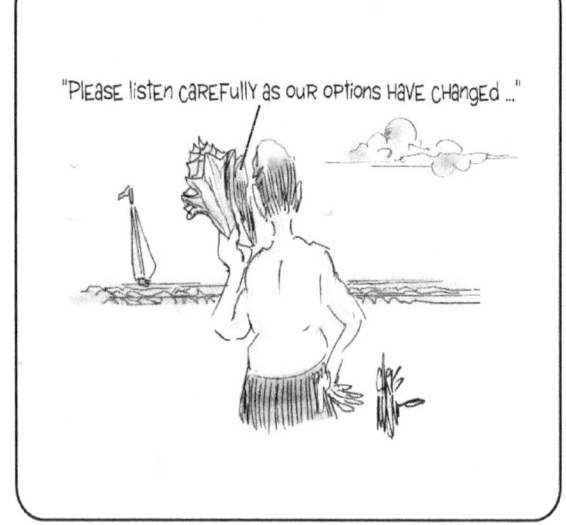
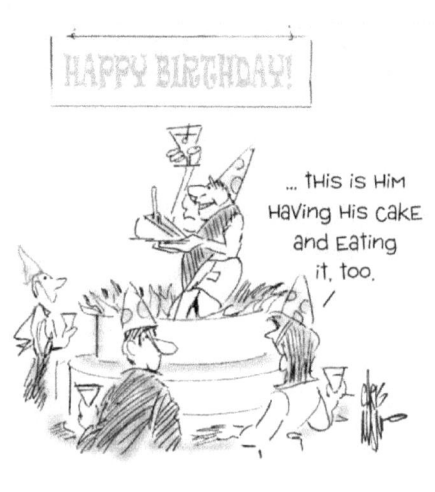
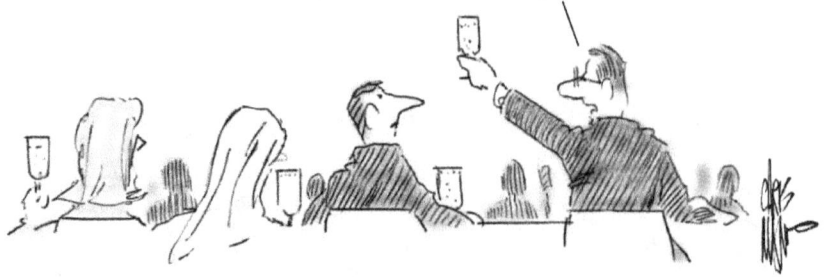

Cartoon REFUGE
Summer 2024

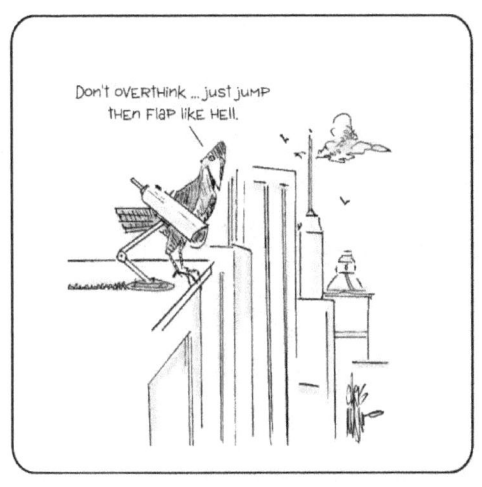

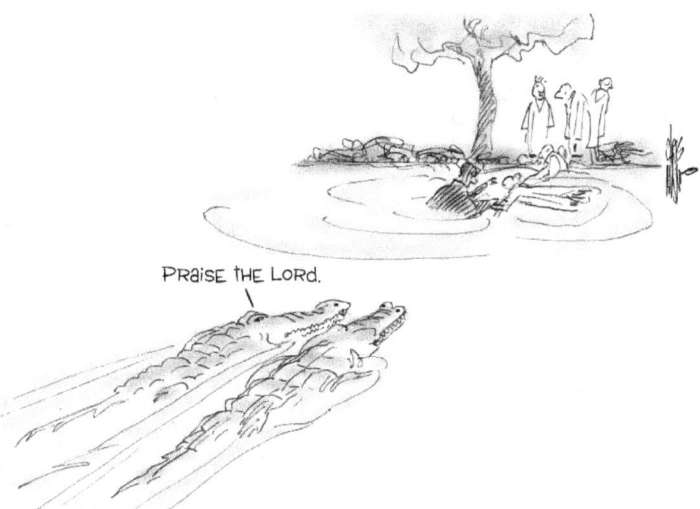

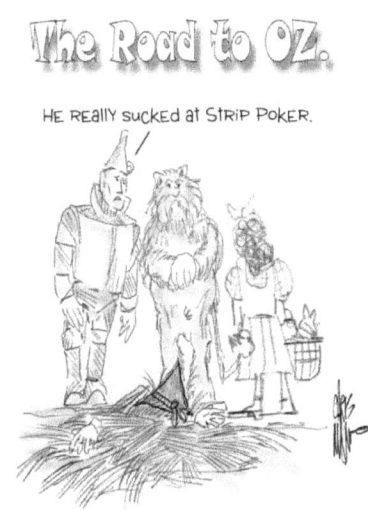

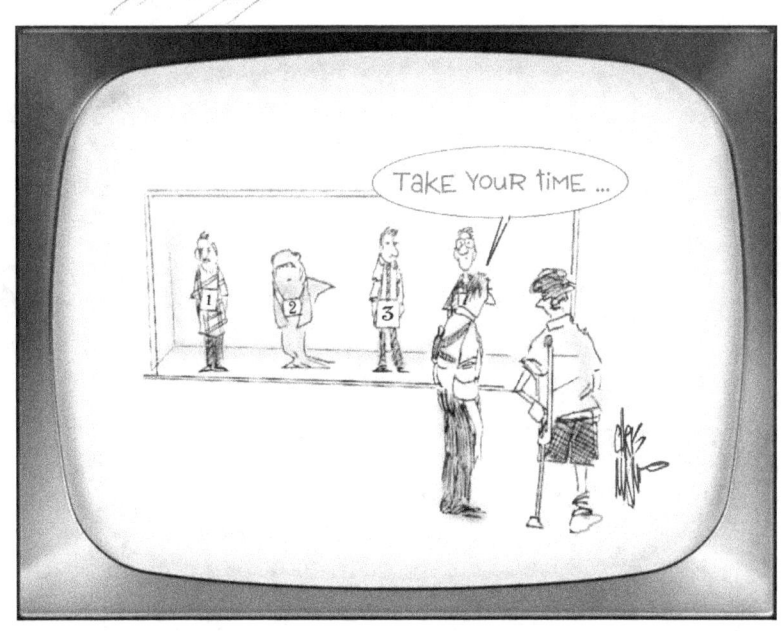

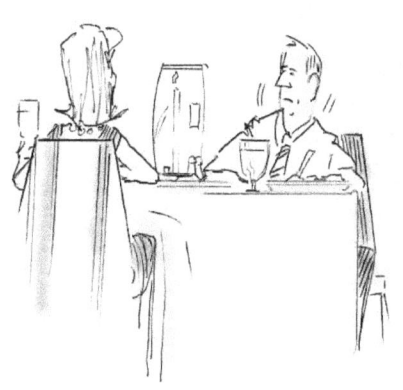

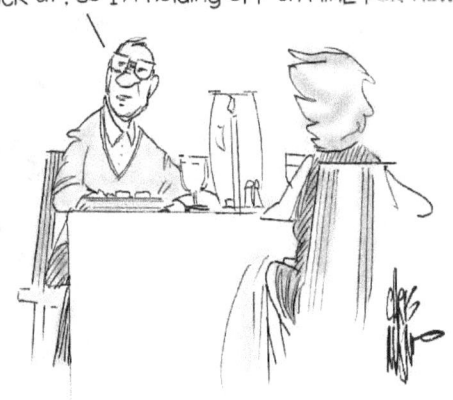

Cartoon REFUGE
Summer 2024

 Fall Edition coming soon!

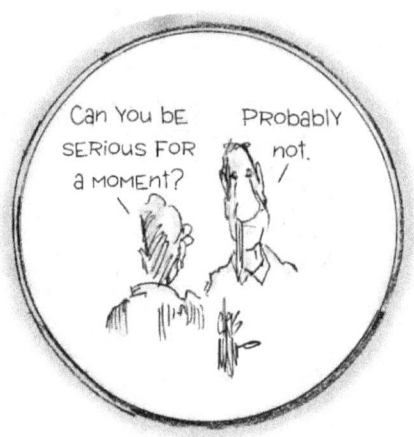

Chris Manno is a freelance cartoonist whose work is featured in books, periodicals and online platforms worldwide.

Cartoon Refuge Fall Edition

Get all issues from Amazon here:

www.ingramcontent.com/pod-product-compliance
Lightning Source LLC
Chambersburg PA
CBHW062316220526
45479CB00004B/1190